DESIGNING WEBSITES://
FOR EVERY AUDIENCE

DESIGNING WEBSITES ://
FOR EVERY AUDIENCE

< ilise benun >

DESIGNED BY LISA BUCHANAN

HOW
DESIGN
BOOKS

Other fine HOW Design Books are available from your local bookstore or direct
from the publisher.

07 06 05 04 03 5 4 3 2 1

Library of Congress Cataloging-in-Publication Data

Benun, Ilise, 1961-
 Designing websites for every audience / Ilise Benun.
 p. cm.
 Includes index.
 ISBN 1-58180-301-X (pb : alk. paper)
 1. Web sites--Design. I. Title.
TK5105.888 .B453 2003
005.7'2--dc21

 2002032869

Disclaimer: Every effort has been made to acknowledge the copyright holders
of each of the Web sites featured in this book. HOW Design Books and the author
would like to apologize if there are any inadvertant credit omissions.

Note: The images corresponding with the interviews in each chapter are stock
images and do not depict the actual people interviewed.

Edited by Amy Schell
Design by Lisa Buchanan
Interior production by Cheryl VanDeMotter
Production coordinated by Sara Dumford
Author photo ©2002 Craig Wallace Dale

ABOUT THE AUTHOR

Ilise Benun is a writer, consultant and speaker. She is a recognized expert on marketing for creative professionals, and conducts seminars and workshops on the human element of self promotion and online marketing for a wide range of industry and trade associations. Benun is the author of *Self Promotion Online* (HOW Design Books, 2001) and two guidebooks, *133 Tips to Promote Yourself and Your Business* and *Making Marketing Manageable*. Her work has been featured in magazines such as *HOW, Inc., Working Woman, Essence* and *Self,* and for 10 years she published a quarterly newsletter, *The Art of Self Promotion.* Benun also works privately with clients to promote their services. For more information, visit www.artofselfpromotion.com.

ACKNOWLEDGMENTS

Like the creation of a Web site, this book has been a long process and a complete collaboration. At the beginning, all I had was an idea in which readers might show an interest. My challenge was to figure out how to turn that idea into a book.

One of the beautiful things about the Web is that people respond to strangers, so while I was writing, I took full advantage of that. I enlisted (and received) the help, feedback and assistance of everyone I could find: site designers, usability engineers, and business owners trying to figure out their own Internet needs. I interviewed many people about many sites, although most of these interviews didn't even make it into the final draft of this book. As I tried to figure out who to talk to and what questions to ask, these people planted seeds that blossomed into ideas and set me on a path that eventually led here. I am grateful to all of them. Their ideas are the foundation upon which this book is built.

I am grateful to my friends and family—especially Mike—who participated in and supported this project, even though many didn't really understand what it was all about.

And I am especially grateful to my teachers and mentors at the Relationships Lab who, at the beginning of the process—when I had only a vague concept of what this book could be— taught me to trust that it would come together. They were right. It has.

Introduction 8
CHAPTER 1: WHY DOES USABILITY MATTER? 10
 Understanding your users 12
 Principles & qualities of successful usability 20
Sites featured 138
Addtional Resources 139
Index 140
Permissions 143

3
P.52 SHOPPERS

Smith & Hawken 54
Castor & Pollux Pet Works 58
Ashford 62
Consumer Reports 66
Staples, Inc. 69

2
P.30

LEARNERS

Breastcancer.org 32
Government of Alberta (Canada) 37
ExploreMath 41
The Wall Street Journal Online 44
Becoming Human 48

Schwab Foundation for Learning 75
Volunteermatch 78
Nerve.com 82
Design For Community 86
Bambino's Curse 89

4
P.72 CONNECTION SEEKERS

TABLE OF CONTENTS

7 FUN SEEKERS P.122

Murder by Numbers	125
Jeepers Creepers	126
James Bond	128
Online Classics	130
Zoog Disney	134

5 TRANSACTORS P.92

H&R Block	94
Better Online Banking	97
Transportation.com	98

6 BUSINESS BROWSERS P.106

Tripwire, Inc.	108
Deerfield, Inc.	111
Berlitz, Inc.	114
FTL Happold	118

INTRODUCTION

During my thirteen years as a marketing consultant, one of my most persistent tasks has been to remind designers and other creative types I work with to think first of their audience when designing a brochure, direct-marketing letter or any other self-promotional tool.

Sounds easy, but this is a huge challenge. You want the art and the design to speak for themselves, regardless of who sees the work. But in marketing, before you decide how to promote a product or service, it's crucial to know who your market is and what they need to see.

When my clients started designing Web sites, I noticed that although their creations were beautiful, they seemed aimless. When I asked who their market or users were, these designers had only a very vague idea (and certainly no real data or information) on which to base their designs. They were focused almost exclusively on the *appearance* of the sites they designed; whether or not the design would *work* was usually someone else's territory.

This struck me as odd, because most designers know that effective marketing requires a constant effort to step outside your own shoes. So too with Web design: you must substitute your market's perspective for your own. This may entail a little mind-twisting and some actual research, but it is very possible and very effective.

This concept was the seed of the idea for this book, in addition to my personal interest in trying to understand the way our minds work—an important element of usability. It seemed to me that if designers (especially those with a background in print) knew more from the outset about what works and what doesn't for different kinds of users, they would be better Web designers. "Does this work?" should be on par with "How does this look?"

So this book is not Ilise Benun's Usability Rules for Web Design. In fact, you'll find no rules here. Instead, you'll have the opportunity to hear from top usability experts and Web designers to learn how they turned an idea into a functional, well-designed Web site. The examples are detailed case studies of sites that received "usability makeovers" or sites that took principles of usability into consideration from the beginning. You'll see and learn what didn't work and why, and how designers attempted to resolve problems as their Web site evolved. You'll also see what does work and why, and how beauty can mesh with functionality.

<chapter>

WHY DOES USABILITY MATTER?

Here's the scenario: you've got a know-it-all client who hires you to redesign a Web site. You have a very small budget, no prior experience with this client, and no idea what the users of their site need or want. They give you ten business days to come up with a prototype and two months to launch the site.

Not your ideal project, but you take it because you need the work—not to mention more examples of Web design for your portfolio. After working on this project for sixteen hours a day and six days a week, you get it done. It's a beautiful site and the client likes it, so the site launches...but two months later you still haven't been paid, and the client comes back complaining that although it looks great, it's unusable.

What could you have done to prevent this disaster? What can you do to make sure it doesn't happen again?

Read this book. It will give you the basics of usability from a visual design perspective, and lots of resources for learning more.

UNDERSTANDING YOUR USERS

Users. Sounds like a bunch of addicts.

According to Web designers at 37signals.com, the people who visit Web sites aren't "users," "click-throughs," "hits," "numbers on a spreadsheet," or some other dehumanizing jargon term. They're your spouse, your mom, your friend, and the guy who sits in the next cubicle. They're real people.

In fact, we are *all* users, and we all have opinions, preferences and pet peeves about what works—and what doesn't—on the Web. But it's unlikely that you, the designer, are the target audience for most of the sites you create, so don't make assumptions. Do research. Talk to your users. Interview them. Find out what they need and what's not working for them. Focus on those who mean the most to your site. Instead of guessing, find out exactly which browser, screen resolution and bandwidth they have, then design within those constraints for the best user experience possible.

Most users have no idea whether a site is well designed. What looks crude to a very experienced graphic designer might look advanced to those with no technology or design experience. They know only whether what they find is useful or useless, and whether theirs is a positive or negative experience. This book will help you create that still-too-rare phenomenon: a Web site that allows users to easily find what they came looking for.

<HOW HAVE THINGS CHANGED?>

During the dot-com boom of the 1990s, all you had to do was launch a Web site and wait for users to come. And for a while they did, because it was all so new and everyone was curious. But things changed and the hype died down. The Web isn't so new any-more, and as it settles into its place in our lives, we have begun to form habits.

Over time Internet users have become more purposeful, efficient, and self-assured in using the Web and e-mail to support some of life's most important activities, according to "Getting Serious Online" from the Pew Internet & American Life Project. People are using the Web more often to conduct business but spending less time per session, aiming to get offline as quickly as possible. As Americans gain experience online, they use the Internet more often for their jobs; to make online purchases and carry out other financial transactions; and to write e-mails with more significant, intimate content. "The Internet has gone from novelty to utility for many Americans," says Lee Rainie, Director of the Pew Internet & American Life Project, "They are beginning to take it for granted, but they can't imagine life without it."

Recent studies by Jupiter Media indicate that visits to Web sites are concentrated in fewer places than they were a few years ago. People stick to a half-dozen sites for news, sports scores, airline tickets and other things they need regularly. More and more use the Web for online chores like checking bank balances, buying gifts or getting the weather report. Very few go online to wander aimlessly. For some, visiting a new Web site is like traveling to a foreign country where new, exciting and anxiety-inducing experiences await them, so they have to be in the right frame of mind.

According to a March 28, 2002 *New York Times* article, "As the Web Matures, Fun is Hard to Find," "Users are less inclined to hunt for innovative sites because many of them require plug-ins or browser updates that force users into bothersome downloading. Entertainment sites, for example, usually require a program like QuickTime," a downloadable program that enables users to play and manipulate synchronized graphics, sound and video.

Most people go online to work or to educate themselves, to transact business or to do research. And they're often in a hurry, impatient, in "cross-it-off-my-list mode." This means they may have very little patience and less tolerance for fancy "eye candy," confusing navigation or heavy, slow-loading graphics. Sites that are fast-loading and easy to use draw more traffic than their flashier competitors.

An experience on a Web site unfolds over a period of time as the user navigates through its virtual space, so anyone trying to connect with or engage an audience through that site must treat the user's time as the ultimate resource. Difficulties quickly translate into frustration for the user; for the Web site, they translate into lost opportunities and, potentially lost revenues. If a Web site is not designed to meet the users' needs, users will avoid the site altogether. The challenge is to create sites that balance attractive design with appropriate usability for the intended audience.

<DESIGNING FOR THE WEB IS A WHOLE DIFFERENT ANIMAL>

The Web is neither fixed nor passive like a printed piece; yet most early Web sites looked a lot like printed pages pasted onto a screen. Today, Web design is much different from print design; it's more like industrial or product design. Industrial designers have to make something functional, aesthetically pleasing, and well constructed, then test it on real people to determine whether it works for the intended users.

Web design is also a collaborative process—more akin to making a film, with the design being just one discrete element

of the project. Most Web projects require teamwork, and the talents of many different people with different skills: one maps out the information architecture, one establishes the brand attributes, another does the information design, and yet others create the visual design, write the code, test the application, and write the copy. On some large projects, many things may happen before the designers even enter the process: proposals, technical program statements, content surveys and interaction design schematics.

Designers generally are responsible for what's called the "look and feel" of a site, but Web site design involves so much more than what the site looks like. When Web sites were simply brochure-ware, usability was not particularly important. There wasn't much to do at a Web site but gather a little information. Now, however, Web sites are not only more interactive, they are more akin to software applications than to brochures. Web designers must not only design the look and feel, they must also design interfaces (what happens when the user performs an action) and interactions (how things are organized).

Though the Web is still primarily a text-driven medium, its rules are not the same as those of print. Unlike print, a Web site must reconcile format limitations with inter-activity and the quick-click mentality. David Weinberger, philosopher and author of *Small Pieces Loosely Joined*, points out that the Web is a series of documents, which he considers a good thing, since "we are all intimately acquainted with the operating instructions for documents." In fact, the very architecture of the Web has to do with linking pieces of content, so much of effective Web design is about organizing and classifying that content so that it can be easily found and read, listened to or viewed.

"DESIGNERS MUST REALLY UNDERSTAND USERS. YOU MUST IMMERSE YOURSELF IN THE DETAILS OF THE USERS, BECAUSE IMMERSION MAKES YOU EMPATHETIC. YOU MUST HAVE A COGNITIVE UNDERSTANDING ABOUT BEHAVIORAL AND DEMOGRAPHIC INFORMATION. **[NOTHING SHOULD BE ARBITRARY. THERE SHOULD BE DISTINCT REASONS FOR EVERY DESIGN DECISION, SUCH AS THE TONE AND TINT OF A PARTIC-ULAR HUE, THAT REFLECT USER BEHAVIORS, USER GOALS, BUSINESS OBJECTIVES, OR TECHNOLOGICAL CONSTRAINTS.]** IDEALLY, THIS ALL WORKS IN HARMONY. THEN YOU MUST RIGOROUSLY MEASURE AND VALIDATE THAT EVERYTHING WORKS."

—PARRISH HANNA, FORMERLY OF HANNA HODGE

<WHAT IS USABILITY, ANYWAY?>

Usability is not a new thing. As humans, we've always tried to make our tasks easier to achieve. As one expert notes, "The first usability engineer was the one who said 'Look buddy, this axe is very sharp, but it's hard to keep the end from flying off once you really get going with it.'" Many definitions of usability exist, some technical, some colloquial. Simply put, usability describes the relative ease with which a person can learn about and use a product. A door with a handle on the outside that pushes instead of pulls is a simple example of poor usability. Similarly, a phone with lots of buttons but no explanation of how to use them isn't usable.

For the purposes of this book, we'll use this definition of usability on a Web site:

A usable Web site is one that allows its users to do what they need to do, or get help easily, without becoming frustrated.

Many different things can affect a site's ease of use, any of which can aggravate and confound users, and ultimately impede business. Slow-loading graphics are the number one complaint. Inconsistency is another major offender, whether it occurs because navigation buttons change or text links are named differently from page to page, or because the layout varies noticeably from section to section. If a site is too filled with visual clutter, the user's eyes may be over-stimulated and important features may be lost in the chaos.

Usable sites are clearly organized and easy to navigate. Hallmarks of good usability include minimalist design, fast page loading, contingency design (devising ways to deal with potential glitches), effective error management (letting the user know how to correct a mistake), intuitive navigation, and simplicity. In short, they support the tasks of the intended users.

Mark Hurst of Good Experience (www.goodexperience.com) sees usability as the tiebreaker when all other things are equal: of two sites offering the same services or products, the more usable will be the more successful.

<CAN GOOD DESIGN AND USABILITY COEXIST?>

Yes, of course, and they can coexist beautifully! Achieving this union requires a dedication to understanding the people who visit a site, appreciating their task-oriented goals, and creating an attractive environment in which their needs are met. When this is accomplished, there is beauty in the clarity that comes when technology simplifies a complex process; beauty in a back-end function that makes the site function impeccably even though the user will never see it. The intention of this book is to show you examples of sites created by designers who not only take their users into consideration, but put them at the forefront, and design sites that are both beautiful and usable.

HOW THE EXPERTS DEFINE USABILITY

The International Standards Organization (ISO) offers a technical definition for usability: "The extent to which a product can be used by specified users to achieve specified goals with effectiveness, efficiency and satisfaction in a specified context of use."

Steve Krug, author of Don't Make Me Think, *writes that "usability really just means making sure that something works well: that a person of average ability and experience can use the thing—whether it's a Web site, a fighter jet or a revolving door—for its intended purpose without getting hopelessly frustrated."*

Jakob Nielsen, usability author and guru, says, "User experience on the Web can be loosely defined as the sum total of a user's satisfaction with your site. System usability, which is closely related to user experience, has many components, including ease of learning, efficiency of use, memorability, reduced number of user errors, and subjective satisfaction."

Jared Spool, founder of User Interface Engineering, says that usability is achieved when "users can accomplish their goals."

<DESIGN FOR WHAT USERS WANT>

Every person performs several different roles throughout the day. An information-seeker at work may be a fun-seeker at home. For example, at work, Bob is looking for a fast, cheap wholesaler between conference calls. During lunch, he might check his stock portfolio, glance over the day's headlines and print out a few articles for the train ride home. After dinner, he may do some online research about the breast cancer that afflicts his mother, then go to a chat room for adult children of breast cancer survivors to ask a few questions. Later, he might visit a few jewelry Web sites to look for a birthday gift for his wife. Finally, he may play a video game to relax before bed. During each of these activities, Bob's mood and mode shift.

What role does a user like Bob play when he visits your site? What does he expect to do there? Thinking about the user in this way can help you design with usability in mind.

Remember that usability is contextual: it is in the eye of the beholder, not the designer. There are no hard and fast rules, although we will offer some guidelines in the pages that follow. It all depends on the users: their needs, goals, and technical limitations— not to mention their Web-savviness, online habits, and mood. Even the user's environment can affect usability. Careful designers will consider these variables from the beginning of the process, not just at the end.

<DESIGN FOR REAL PEOPLE>

How do you learn to understand the user? (Wouldn't it be nice if this chapter held that secret!) Well, it requires a mindfulness of other people that is very hard to maintain, especially in a culture that celebrates individuality and urges us to focus on ourselves.

The common thread shared by the most successful online businesses is a focus on

user experience. Good usability results from understanding the needs and preferences of your users and allowing form to follow function. The most compelling design solutions are simple and naturally easy to use (sometimes referred to as intuitive). But such ease can be achieved only when you know and understand the actual users. Do your best to put yourself in someone else's shoes, and back up your observations with interviews, surveys and market research.

<DESIGN WITH HUMAN LIMITATIONS IN MIND>

All human beings have limitations: physiological, psychological and cognitive—not to mention those imposed by the equipment we use. Designing and building a Web site for the user means seeking to understand the mind and behavior of a particular group of human beings, and of human beings in general. Usable Web sites acknowledge human tendencies and limitations and make allowances for them in their overall design.

Cognitive limits refer to our capacities for reasoning, memory and perception. For example, there is a limit to the amount of information one person can understand or remember. Studies show that most people cannot keep track of more than six or seven independent pieces of visual information at any given time, even under favorable conditions. This is important to know when designing a system with lots of information to convey. Easy-to-use, easy-to-understand visual navigation can compensate for the weaknesses of human memory.

WHAT DO PEOPLE LIKE?

People like:

- [] *ease of use*
- [] *speed*
- [] *practicality*
- [] *credibility*
- [] *simplicity*
- [] *support*

On the homepage of copywriter Bob Bly (www.bly.com) the left navigation bar originally offered seventeen options to choose from, with no hierarchy or categorization. The revised navigation bar broke the choices up into four categories, making it easier for users to decide where to go.

The manner in which users visually scan the screen strongly influences their ability to absorb and respond to instructional content and navigational aids. Who users are affects what they can absorb. Take the simple example of older people who may not see tiny text. If you didn't know that seniors were the main users of your site, you might select tiny text for aesthetic reasons (or because you work on a large monitor), thereby rendering the site unusable for the intended users.

Usability requires an appreciation of human physiology, of the way sensory systems (sight, hearing and touch) relay information. Remember that people can be sidetracked by the smallest movement in the peripheral part of their visual fields. Web site layouts should reflect that knowledge, so moving or blinking visuals should be used very carefully.

Knowing some behavioral psychology is integral to usability. Predicting reactions, reflexes, and how users will interact with various Web environments and stimuli is key. This means anticipating visitors' needs, prioritizing your messages and tasks, predicting which questions users will ask (and in what order), and quickly providing the answers.

Because so much of what's on the Web is educational, usability also requires an understanding of how people learn. A variety of presentation styles can help accommodate the varied needs of concrete experiencers, reflective observers, abstract conceptualizers, and active experimenters.

<USERS HAVE FEELINGS>

Marisa Weiss, M.D., a radiation oncologist and the founder of Breastcancer.org, had trouble finding an appropriate design firm to create a Web site for breast cancer patients. The developers she encountered were generally healthy men under forty who hadn't struggled with illness or with the medical system; therefore they were unfamiliar with the needs of female cancer patients. Unfamiliarity is no crime; it just means that more research will be required before the design process itself can begin. Designers who are unfamiliar with their users' needs must listen to potential users very carefully.

But most of the designers/developers Weiss found didn't listen. "They were designing for themselves," she says. For a page promoting a live on-site chat regarding tips for summer—a difficult and emotional time for breast cancer patients who are uncomfortable with their bodies—the graphic images chosen by these "young guys" depicted a "babe" with a plunging neckline and a martini. Good design should reflect a sensitivity to the user's situation and values, and avoid anything that might be seen as offensive.

UNDERSTANDING MEMORY

Have you ever cut a piece of text or an image and then forgotten what it was before you could even paste it? An awareness of our limited ability to encode, store and recall information plays a crucial part in developing a usable Web site. If users can't remember a piece of information they need from one page to another, they're going to have to keep clicking back and forth and they'll become frustrated.

Recent studies show that users' memory capacity in a dynamic environment such as the Web is only about two or three chunks, which means that as users navigate through your site and try to digest its content, they might not be able to remember information from just a page or two back. If users must continually click from page to page looking for what they want, they may get distracted and forget what they are looking for.

Page breaks inserted for aesthetic reasons or for the convenience of the designer may turn out to be inconvenient for users. All information that a user must remember in order to continue through a site should be easily accessible, preferably without requiring the user to return to a previous page. The scroll feature allows users to scan a page quickly while searching for specific information. Another advantage of combining important navigational information on a single screen is that the page may be printed out more easily.

\<DESIGNING FOR MULTIPLE USERS\>

Usability must also consider how many different kinds of users will be accessing a specific site and how many tasks they need to perform there. If your site is for only one person performing one task, then it should be easy to design an interface that will be completely effective for that user. It's rare, however, that a site is targeted to a single user with a single goal, or even to many users with a common goal. As the number of tasks and users increases, so does the challenge of designing a usable interface.

The Institute of Applied Aesthetics (www.lpt.fi/io/index.html), an independent academic institute based in Finland, needed a site for a diverse global audience. Konsta Korhonen, a visual designer and Webmaster at IIAA, was charged with creating an aesthetically pleasing site (about aesthetics, no less!) that worked well in browsers across the spectrum: from text-only browsers to Netscape 6.0. Because many visitors to IIAA's site log on from universities, schools and libraries, where old computers are the norm, Korhonen used text-only browsers as the basis for designing the plain HTML navigation.

On the IIAA Web site, an HTML design with brushstroke graphics was discarded because a large segment of its global user group might not be able to view it effectively on older equipment.

The final IIAA homepage.

THE DIGITAL DIVIDE. WHO'S ONLINE?

By Geography

In the United States., Internet access is more affordable than in other parts of the world. Americans generally pay a flat-rate fee per local telephone call, a much cheaper alternative to the per-minute fees incurred by telephone users in the United Kingdom and other countries. About half the country's population uses the Internet. This is in stark contrast to most of the rest of the world. The United States has more Internet users than all of Asia, which has over half the world's population. There are about as many Internet users in New York City as in all of Africa.

By Race

There is a noticeable divide along racial and ethnic lines in the United States. According to a 2001 study by the U.S. Department of Commerce, Asian Americans, who make up about four percent of the U.S. population, have the highest rate of Internet penetration. Asian Americans and whites have the highest penetration rates—about 60 percent. At the other end of the spectrum, only about 40 percent of blacks and 31 percent of Hispanics, the two largest minority groups in the U.S., have Internet access.

By Income

According to a 2002 U.S. Department of Commerce study, differences along income and education lines are also large. Those who earn more money and those with more education are far more likely to own computers and have Internet access. The study found that over 80 percent of individuals with a post-graduate education had Internet access, compared to only 40 percent of individuals with only a high school education.

By Gender

Two reports in 2000 concluded that the percentage of men online in the United States differs with that of women by less than one point, a clear reversal of the male-dominated Internet.

By Age

In 2000, Internet market research firms Media Metrix and Jupiter Communications found that the biggest increase in Internet users came in girls aged twelve to seventeen, who were attracted by chat rooms and Web sites for popular teen magazines, fashion styles, and rock bands. People over the age of fifty-five seem to be attracted to sites dealing with genealogy and health.

By Bobson Wong, executive director of the Digital Freedom Network (www.DFN.org)

<CREATING PERSONAS>

When creating characters, actors and play-wrights often create a back story, a history about the character that is never revealed in the final performance but which is an essential part of the rehearsal process, informing the development of the character.

Cooper Interaction Design (www.cooper.com) developed a similar concept for Web design. Rather than designing for all people or for the "average user," the Cooper approach suggests that designers focus on the unique goals of certain personas in order to develop a product or Web site that satisfies the needs of many users.

A persona is a profile of an archetypal user. It includes a name, a social history, and a set of goals that drive the design of the Web site. By closely adhering to the goals of a specific persona, designers can satisfy the needs of the many users who have goals similar to those represented by the personas.

Brian Ragan used this approach when redesigning the global Berlitz site. "This is an organic approach that grows from the bottom up and puts team members in touch with how people will end up using the site," he says. "Unfortunately, however, this process is not often used due to time, money or the ego of a client who believes they have it all figured out." (See more about the Berlitz makeover in chapter six.)

TIPS FOR CREATING PERSONAS

A persona is a user archetype you can use to guide decisions about product features, navigation, interactions, and even visual design. By designing for the archetype—whose goals and behavior patterns are well understood—you can satisfy the broader group of people represented by that archetype.

In most cases, personas are synthesized from a series of ethnographic interviews with real people, then captured in one- to two-page descriptions that include behavior patterns, goals, skills, attitudes and environment, with a few fictional personal details to bring the persona to life.

It's easy to assemble a set of user characteristics and call it a persona, but it's not so easy to create personas that are truly effective design and communication tools. If you have begun to create your own personas, here are some tips to help you perfect them.

Personas represent behavior patterns, not job descriptions. A good persona description is not a list of tasks or duties; it's a narrative that describes the flow of someone's day, as well as their skills, attitudes, environment and goals.

Keep your persona set small. Ideally, you should have only the minimum number of personas required to illustrate key goals and behavior patterns.

Add life to the personas, but remember they're design tools first. Sometimes it's easy to focus too much on a persona's biography. Personal details are the fun part, but if there are too many of them they just get in the way. To avoid this problem, focus first on the workflow and behavior patterns, goals, environment, and attitudes of the persona—the information that's critical for design—without adding any personality. Once you have the critical design information, add just one or two personal details, such as what your persona does after work (she goes home to watch old movies with Claude, her cat), or what personal touches there are in her workspace. Without a little bit of personality, personas can easily turn into generic users instead of precise design targets.

Use the right goals. Each persona should have three or four important goals that help focus the design. Keep in mind that goals and tasks are different: tasks are not ends in them-selves, but are merely things we do to accomplish goals. Not just any goals will do, though, so it's important to understand which types will help you make design decisions. Most persona goals should be end goals that focus on what the persona could get out of using a well-designed product or service.

By Kim Goodwin, Director of Design at Cooper Interaction Design (www.cooper.com)

<UNDERSTANDING THE USER-CENTERED DESIGN PROCESS>

A July 1998 article by Raïssa Katz-Haas in *Usability Interface* (the Society of Technical Communication's newsletter) offers a usable description of user-centered design:

User Centered-Design (UCD) is a philosophy and a process. It is a philosophy that places the person (as opposed to the "thing") at the center; it is a process that focuses on cognitive factors (such as perception, memory, learning, problem solving, etc.) as they come into play during peoples' interactions with things.

In her article, Katz-Haas suggests involving users from the beginning by:

- Discovering (through interviews and surveys) their mental models and expectations

- Including them as an integral part of the design/development process and team

- Observing them at their workplace; validating your assumptions about them; analyzing their tasks, workflow, and goals

- Eliciting feedback via card sorting (a technique in which the user maps out the site using index cards), paper prototypes (a series of screens on paper that demonstrate one particular path or task sequence), and think-aloud sessions (where instead of asking questions, you listen to the user thinking aloud as they navigate)

KNOW YOUR USERS

Ask these questions to guide your development and design decisions:

- *How much experience do the users have with computers? The Web? Your subject matter?*

- *What are the users' working and Web-surfing environments?*

- *What hardware, software and browsers do the users have?*

- *What are the users' preferred learning styles?*

- *What language(s) do the users speak? How fluent are they?*

- *What cultural issues might there be?*

- *How much training (if any) will the users receive?*

- *What relevant knowledge and skills do the users already possess?*

- *What functions do the users need from this interface? How do they currently perform these tasks? Why do users perform these tasks the way they do?*

- *What do the users need and expect from this Web site?*

- *What are the users' tasks and goals?*

- *What information might the users need, and in what form do they need it?*

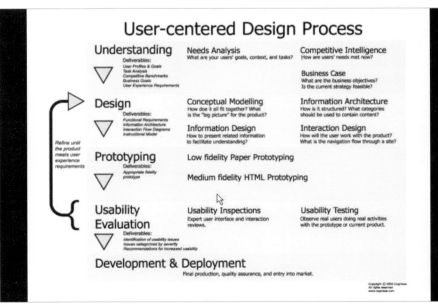

This diagram, created by usability engineer Jess McMullin, clearly describes the User-Centered Design process.

If the audience laughs, a comic is funny.
It's the same with usability: if the intended users can achieve
their goals on your site, it's usable.

Ed Fladung, a designer of movie Web sites (see chapter seven), thinks of usability in shades of gray. "It's not really about whether the usability is good or bad, or whether or not the lowest common denominator will 'get' the design. It's about designing a navigation scheme that serves the positioning and subject matter of a film, successfully gives the user a good idea of what the film is about and motivates the user to go to see it."

\<USABILITY MYTHS REVEALED\>

Usability gurus prance around making proclamations about good and bad usability, offering rules for everyone to follow. Here are some rules that get bandied about, but which aren't necessarily valid:

People don't like to read...so limit the text. Well, it depends. Although reading online is different from reading on paper, reading and writing are essential to what we do with computers. People read what they're interested in, no matter what the medium.

People don't like to scroll...so keep the pages short. Well, it depends. While it's true that some people scroll reluctantly (and others don't even notice that it's an option), studies show that if users are confident that they'll find what they're looking for below the fold, they'll scroll to find it.

A Web site must have a search button. Well, it depends on the quality of the search engine used, the kinds of items users want to search for, and how close the keywords in the system are to the words in a user's mind. If searching on a site continually frustrates users, it may be better not to have that option.

People like to try new things. Well, it depends. Users should not have to learn new things to perform familiar tasks. When they click on a link, something should change and it should be the change they expect. They should be able to easily tell what is a link and what is not. While experimentation is good, some conventions should remain the same.

It's impossible to offer rules that apply to all sites. It's difficult even to offer guidelines; however, that's what we've tried to do in this chapter.

Tests show that users come to The Wall Street Journal's *site (http://online.wsj.com), first and foremost, to read the news— so there had better be some text available for them to read. Users are also more likely to print one long, scrolling page than several shorter pages, which require more effort and time.*

<FOLLOW CONVENTIONS WHENEVER POSSIBLE>

By virtue of their wide use on the most popular sites, de facto conventions have sprung up. These conventions, such as using tabs on Amazon.com and AOL, have created expectations on the part of the users, who bring a foundation of experience—from the real world and from prior Web experience—to every site they visit, no matter what mode they're in.

Users should not have to learn new things to perform familiar tasks. When they click on a link, something should change and it should be the change they expect. Users should be able to easily tell what is a link and what is not. They should be able to hit the back button and return to the page they just left.

Now, you don't have to follow the conventions on every site. In fact, most conventions are far too young to be adopted without question anyway because they may not be the most effective solutions. Nonetheless, they are often used because they are familiar, and the majority of users therefore will not have to waste time learning from scratch. It is wise, then, to consider taking advantage of what your intended users already know.

If you choose not to follow convention by hiding the navigation or omitting the back button, you may alienate users. Breaking with convention is not a crime, but it should be done consciously and for a specific reason. Some of the sites featured as case studies later in this book demonstrate why some conventions may be disregarded.

<FACTORS YOU CAN'T CONTROL>

In print, you are accustomed to controlling everything about the viewer's experience—from layout to type size—in order to achieve a certain effect. This is possible because a printed piece is static. However, because the screen is an inherently unstable and dynamic medium, designing a Web site requires you to give up a certain amount of control. Instead, you must design within the technical constraints presented by the intended user.

Everyone has a different computer, a different monitor, different settings and preferences for everything from text size to screen resolution, a different modem speed, bandwidth, and so forth. The myriad combinations of variables make each user's experience different. Moreover, designers often have more advanced equipment than the common person, so creating a uniform design to accommodate all these variables may seem close to impossible.

Each system and Web browser has its own quirks, some of which affect the following:

- **Offset.** The space between the edge of the browser window and where the content begins varies from platform to platform.

- **Canvas size.** When the screen resolution of the browser window is set for 600 x 800 pixels, you don't actually have that amount of pixel space available for content. You must allow space for the toolbar which, by default, is part of the browser; so the window area seen by the user will be much smaller than you might expect.

- **Text size.** Although there is very little variation in HTML text size among browsers, there are differences from platform to platform. You can be assured of good display with basic fonts such as Verdana, Arial and Helvetica. Be aware, however, that users can change the default settings for type size and other graphic elements, so your site must be able to accommodate that.

- **Color.** A major difference between platforms is the way they handle *gamma*, or the amount of displayed brightness. That means that any graphic you design on a Macintosh will appear darker and muddier when viewed on a PC. Conversely, any graphic you design on a PC will look somewhat washed out on a Mac.

When designing for specific user groups, find out how up-to-date their hardware and software are. If they're sophisticated users, they may have the latest version; but remember that not everyone rushes out to upgrade his or her browser every time a new one is released. And unless you know that your users are using a less common platform such as Linux or Unix, don't waste time designing for (or conducting usability tests on) such alternatives.

Screen resolution

Screen resolution refers to the dimensions, in pixels, of a screen's display. (This has nothing to do with monitor size. Any size monitor can be set to almost any resolution.) The most common dimensions are 640 x 480, 800 x 600 (the current standard), and 1024 x 768.

It's important to find out which screen resolution the majority of your target audience uses because that will affect the layout of your page. The most crucial content must appear within their screen without scrolling—in other words, above the fold, that most valued area of real estate—so they are sure to see it. The fold may also wrap around the right edge, so anything off to that side would also be behind the fold as well. Use this area only for less important content.

Bandwidth

Bandwidth refers to the size of the pipe through which information travels across the Internet to a user's computer, or the number of "lanes" available on a given part of the information highway. Some users have access to high bandwidth connections—i.e., more lanes—via DSL, cable modem, T1 or T3. Dial-up modems offer lower bandwidth—fewer lanes along which information can travel. Higher bandwidth usually means faster connections, although heavy traffic on the Internet can significantly slow connection speeds no matter how many lanes there may be. Moreover, some of those lanes may be blocked by "accidents" or "construction zones," so that, say, a 56K modem actually may not be able to handle more than 48K.

Because the users' number-one complaint about the Web is that pages download too slowly, designers should be careful not to overload their users' bandwidth capacity with unnecessarily flashy graphics and technical imagery. While high-speed connections are available to an ever-increasing number of users, especially in the business sector, today there are still a lot of people dialing up on modems with 56K or less.

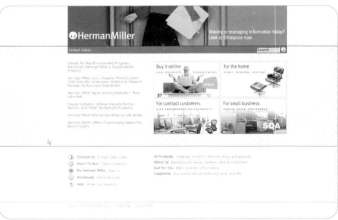

Web pages viewed at different resolutions make objects seem either larger or smaller. A graphic that measures 640 pixels across will fill the entire width of a 640 x 480 screen. The same graphic viewed at a resolution of 1280 x 1024 will take up less than half the screen, leaving a lot of empty space.

Be familiar with the lowest common denominator

There's nothing like the experience of waiting two minutes for a page to load to help you keep your feet on the ground. To stay connected to the experience of your intended user, view your site—throughout the process, not just at the end—on a computer with screen resolution set at 640 x 480, 256-color, running Windows 95 and old browsers (Netscape 6, in particular, is full of lots of unpleasant surprises), with a 28.8 kbps external modem. This set-up represents the inefficient, outdated equipment some of your users may still be using.

Planning for the lowest common denominator doesn't mean your site has to be boring or that you can't use Macromedia Flash. Use JavaScript to detect a particular plug-in or browser level that you can rely on to make your site more exciting, but provide an alternative for those who don't have the latest or the greatest resources.

<GENERAL PRINCIPLES FOR WEB DESIGN>

Let these guidelines provide the framework for your designs. While some of these points may seem like common sense, you may not realize how certain features (or lack thereof) may impact the usability of your site.

Consistency

To prevent confusion and anxiety, a site should be graphically and interactively consistent from page to page, section to section, even subsite to subsite. Pages should share the same basic layout grids, graphic themes, editorial conventions and hierarchies of organization. Users shouldn't have to remember what the elements mean from one page to another; so use the same buttons or interactive icons, the same terminology, the same organization of actions throughout the site to reduce the user's memory load.

Interaction

Interaction should be predictable, visible and reversible. When the user clicks a button, something on the screen should change so the user knows the system has registered the action. When possible, offer a preview of the results of an action. Any delay intrudes on users' tasks and erodes confidence in the system.

Users feel more comfortable with interfaces in which their actions do not cause irreversible consequences. Users should feel confident about exploring, knowing that they can try an action, view the result, and then undo it if the result is unacceptable.

Instruction

Good usability design that promotes multiple open channels of communication between the company and the consumer establishes trust and credibility. Go ahead and tell people what to do; don't make them guess or wonder. Some users like more instruction than others, so knowing your users' preferences is essential to knowing how to assist them. Use text links (such as, "click here to close this box"), title tags, or hovers to give instructions. Let users know how long something will take to download and indicate where their system is in the downloading process.

Choices

Offer users more than one way to find what they're looking for. Allow them to choose the method of interaction that is most appropriate to their situation, and then support alternate interaction techniques. Within the same user group, some may prefer text links to graphic links. Some may always use the search field first, while others may go for the index or site map. Flexible interfaces can accommodate a wide range of user skills, physical abilities, interactions and usage environments.

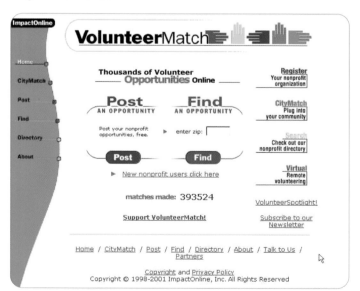

Too many options, as shown on an earlier version of the homepage for Volunteermatch.org, can make a page look cluttered and confusing. Strive for a balance between variety and clarity.

Navigation

There are four main ways in which information can be organized on the Web:

- Hierarchical
- Sequential
- Narrow and deep (with fewer but longer pages)
- Broad and shallow (with more but shorter pages)

Control

Personalization is the ultimate in control, especially on sites that users visit regularly, such as transaction-oriented sites. Allowing users to personalize your site for their interests and preferences can make the interface feel comfortable and familiar to each of them, which leads to higher productivity and user satisfaction. Allowing users to decide how the page is laid out—which elements to hide and which should remain visible, can save them time and hassle when they access frequently used functions. Text size is another element many people have personal preferences for. People with vision problems like to have consistently large text displayed, but many sites take control of text size through cascading stylesheets.

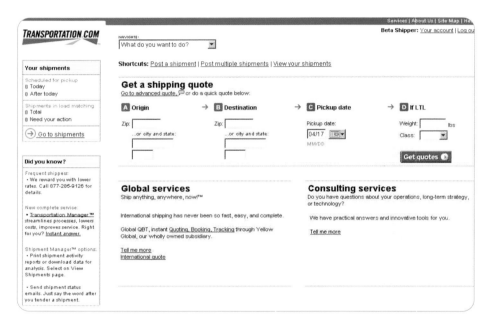

Transportation.com uses sequential navigation to guide users through the site in a logical, linear fashion. A sequentially organized site presents users with a limited range of options and asks them to complete the task at hand before moving on to another set of choices.

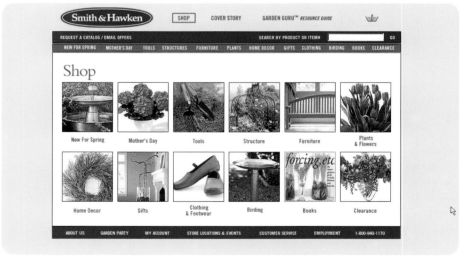

The goal on Smithandhawken.com is to offer customers as many choices as possible, so this site fits into a broad-and-shallow category, while trying not to make the sub-categories too vague or all-encompassing. "We want customers to be able to find what they need with a minimum of clicks and still experience the intrigue of discovering the unexpected," says designer Pete Graham.

Whenever possible, place users in control. Enable them to accomplish tasks through any sequence of steps that seems natural to them. And whenever possible, don't limit them by artificially restricting their choices to your notion of the "correct" sequence.

Usable and successful sites are clearly organized and easy to navigate. They help you determine where you are and where you can go by flattening hierarchies and reducing navigational steps.

To minimize user anxiety, provide ways for visitors to figure out where they are in the context of your Web site. It is uncomfortable to be unable to tell where you are, how you got there, or how to get out. Be kind to your visitors; don't take them into unfamiliar territory without leaving them navigational clues such as descriptive links, site maps, breadcrumb trails and obvious ways to exit every page.

Be sure that your navigation system allows easy access to the breadth and depth of your site. Don't require users to return to the homepage every time they need to backtrack or access a different portion of your site. The bigger and more varied your site, the more important it is to provide good navigational tools.

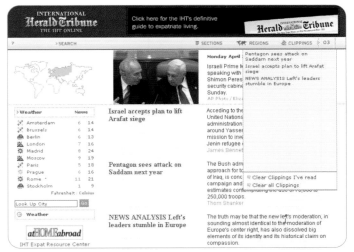

On this site for the International Herald Tribune, the "clippings" feature puts control in the users' hands by allowing readers to select the stories they want to read by clicking on an icon. The icon then flies across the screen into the reader's clippings folder, to be read at his or her leisure.

GENERAL GUIDELINES FOR NAVIGATION

Use text-based navigation. *Since many users see graphics as advertising that could take them off-site, one benefit of text-based navigation is that it enables users to understand the link destinations. Also, users with text-only and deactivated graphical browsers can see the navigation options.*

Use pop-up windows judiciously. *Although many users complain about pop-up windows and newbies are often confused by them, sometimes they are the best choice. Forms that users must fill out, as well as supplemental information that not every visitor needs, may be put into pop-up windows. These are most effective when they aren't the same size or in the same location as the parent window; when they are triggered by a user's action (such as a click), rather than appearing automatically; and when the content of the window is relevant to the action.*

Make sure there's a back button. *Approximately 60% of Web users use the back button as their primary means of navigation, especially when a site's navigation strategy is not obvious. Usability issues surface when the back button doesn't work the way users expect.*

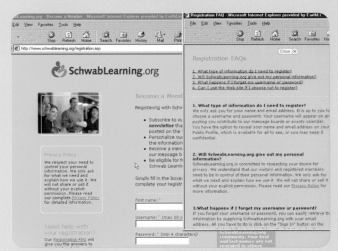

Schwablearning.org uses pop-up windows to provide answers to frequently asked questions, because only some users need them.

<VISUAL PRINCIPLES FOR WEB DESIGN>

Scrolling news tickers...Spinning logos...Frames...Beveled buttons...Pictures...Splash pages...Music...Banner ads...3D elements...Virtual reality...

According to Web designers at 37signals.com, none of these devices is inherently bad. The problem arises when a device is used because it *can be* rather than because it *should be*. "Sure, there are times when light type on a dark background is appropriate, but looking cool isn't reason enough. We believe that 'hip' and 'legible' don't have to be mutually exclusive. We love 'cool' as much as the next person, but we also realize that part of our job is to make people's lives easier, not harder. People don't wake up and say 'I want something to be difficult.' And you never hear complaints that something was too easy."

Here are some guidelines for using visual elements to make a site more usable.

Graphics

Graphic images on a Web site are sometimes used simply for decoration. Often, however, they are navigational tools that allow a user to take an action—but it may be impossible to tell just by looking at the screen. Images to be used as navigational tools should look like action-oriented objects rather than illustrations. Users should be able to determine at a glance whether an image is a useful link or merely an ornament. Similarly, text should not be underlined unless it is a hyperlink, or it may create expectations that can't be met.

Because the Internet crosses cultural and national boundaries, it's wise to choose icons carefully. Images that represent something innocuous in one culture may be misunderstood or misinterpreted by someone from another culture with unfortunate results.

Text

It's not true that people don't read online; if the content is compelling, they'll read it. You can make it even easier to read by organizing text into small, digestible pieces and by using a meaningful hierarchy. Provide clues to help users find the information they want by scanning rather than reading.

Here's what's most usable when it comes to text:

- Sans serif fonts rather than serif fonts, especially in body text
- Nonornamental fonts
- Roman rather than italic characters
- Medium-sized fonts (9 to 11 points for sans serif fonts, 11 to 12 points for serif fonts) for body text
- Upper and lower case rather than all capital letters for body text
- Line lengths of less than fifty to sixty characters long to facilitate scanning
- High contrast between text and background colors (dark text against a light background is most legible)

Layout

Nobody deliberately creates a cluttered page—it just happens when designers attempt to meet every need without first devising an overall plan. A well-organized interface that supports the user's tasks becomes transparent and allows the user to work efficiently. What does it take to create a simple, uncluttered page? Edward Tufte writes in his book called *Envisioning Information*, "It is not how much space there is, but rather how it is used. It is not how much information there is, but rather how effectively it is organized."

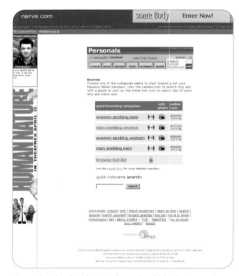

Even the simplest instructions should be kept concise and brief, as shown on this Nerve.com Web site.

The first step in creating an effective layout is to determine the relative importance of the users' tasks and establish a visual hierarchy among them. The most important elements should be the most prominent visually. Basic functions also should be immediately apparent for the convenience of new users, while advanced functions used by more experienced visitors may be less obvious. Keep the number of objects and actions to a minimum while still allowing users to accomplish their tasks. Simplicity is not always simple.

Luke Knowland, Director of Web Production and Development for VolunteerMatch.org (see chapter four) says, "It's a matter of figuring out which data is important to the user, and breaking it down into manageable amounts."

Reduce clutter by eliminating any visual elements, such as decorative graphics, that don't contribute directly to communication. Graphics should be used to illustrate, inform, and aid in navigation. Use white space with visual "breathing room," to visually organize the page, emphasize important elements, and give users' eyes a rest. Also easier on the eyes are invisible table lines, rather than visible ones. If you must use lines, choose light, thin, or dotted ones.

CASCADING STYLESHEETS

Cascading stylesheets (CSS) offer a simple mechanism for controlling the style of a Web document without compromising its structure. By separating visual design elements (fonts, colors, margins and so on) from the structural logic of a Web page, CSS gives you control without sacrificing the integrity of the data, thus maintaining usability in multiple environments. As a result, Web sites that take advantage of CSS are both backward compatible and forward compatible. A CSS/HTML site will look appropriate on the small screen of a Palm Pilot as well as on a 21-inch flat-screen monitor.

In addition, defining typographic design and page layout from within a single, distinct block of code—without having to resort to image maps, tags, and tables—allows for faster downloads, streamlined site maintenance, and instantaneous global control of design attributes across multiple pages. On the down side, some browsers don't support CSS and even those that do may be buggy, so make sure it will work for your users before you decide to employ it.

The average user can't distinguish between a page coded with CSS and one that is not—which makes sense, because it's meant to work in the background. But there are subtle clues a designer may pick up. For example, CSS designs are "liquid," i.e. they expand and collapse to any size browser window rather than being fixed (a condition known as ice design). They also tend to be cleaner, with more white space.

Bambinoscurse.com uses CSS to control its layout. Notice how Babe Ruth's face is in the same place whether you've scrolled up or down on this page.

Color

There are many issues to consider regarding color use on the Web; some subjective, some cultural, some technical. For broad generalizations about color to be useful, they must be considered in the context of a site's message and the demographics of its target market.

Although color can engage users, it can also distract them. Differences in color value and intensity can evoke very different emotional responses. For example, light red is associated with cheerfulness, but bright or dark red can induce irritability. Light yellow-green is associated with freshness and youth, but the darker shade olive is associated with drabness and decay. Light sky blue is associated with tranquility, but the deeper value indigo is associated with depression.

Also, people in different cultures interpret colors differently, so a savvy Web designer can avoid disappointing results and costly reworking by doing some upfront cultural research. White is the color of death in China, but purple represents death in Brazil. Yellow is sacred to the Chinese, but signifies sadness in Greece and jealousy in France. In North America, green is typically associated with jealousy. People from tropical countries respond most favorably to warm hues, while people from northern climates prefer the cooler shades.

And don't forget about color blindness: 8 in 100 males and 1 in 230 females are color blind—which is a significant percentage of the population. You can test how color-blind visitors will view your color scheme by converting it to grayscale or black and white. For the color-blind, WhatColor is a software program that identifies the color name as well as the RGB value.

Web-Safe colors

The Browser-Safe Palette, as named by Lynda Weinman of Lynda.com, is the actual palette employed by Mosaic, Netscape and Internet Explorer. According to Weinman's Web site, "This palette is based on math, not beauty, and only contains 216 colors out of a possible 256. (The remaining forty colors vary on Macs and PCs, so by eliminating the forty variable colors, this palette is optimized for cross-platform use.) The Browser-Safe Palette is useful for flat-color illustrations, logos with flat color, and areas in any image that have a lot of a single color."

Some say that there is no longer any reason to stick to Web-safe colors, as most visitors have monitors that display more than 256 hues. But some are still working on monochrome monitors. As always, the point is that you must consider the needs of your users. When in doubt, choose the Web-safe palette.

After taking all these issues into consideration, the most important thing you can do to evaluate the usability of your site is to conduct user tests. Representatives from your user group make the best test subjects, but anyone will do; the important thing is to test your design on actual human beings. Let them try your design and note any difficulties or confusion they may have. Watch to see what they linger on, and what they ignore. Testers will provide you with numerous valuable insights that will help you refine your design (see chapter five for more information on usability testing).

HOW TO DETERMINE WHETHER YOUR SITE IS USABLE

Is it intuitive?

- *Does it take advantage of users' mental models?*
- *Does it behave consistently throughout?*

Is it visually consistent?

- *Is it easy to learn?*
- *How quickly can novice users perform real world tasks on the site?*

Is it efficient?

- *Can tasks be performed with keyboard strokes?*
- *Does the site reflect a clear understanding of how users do their work?*
- *Are response times fast enough to keep users in a flow state?*
- *How easy is it for users to perform more complex tasks?*
- *How easy is it to use the site with only partial knowledge of "how it works"?*
- *Can common tasks be completed quickly and accurately?*

Is it supportive?

- *Does it allow mistakes to be easily undone?*
- *Does it provide advice? tools? reference materials? access to live help?*

Is it engaging?

- *Do users feel in control?*
- *Do users enjoy their experience?*

USABILITY TESTING

There is no single "right" way to conduct usability testing. The real-world constraints of money, time and company politics are just a few of the determinants of the scope and depth of user testing. The important thing is to do it. User testing often reveals important problems that go unnoticed by company insiders who are too intimately involved with a project.

Reactions from first-time observers of user testing can be quite dramatic. They include bewilderment at how "blind" the test subjects are, hostility and anger at the subjects' "stupidity", and insistence that the sample must be flawed. Finally, it becomes clear that these are not stupid people; they are real people, and if they can't figure it out, it's a good bet no one else can.

Guidelines for effective usability testing:

- *A little goes a long way. Even if you can afford to test only one user, you will learn valuable things about your Web site's usability so you can improve it.*

- *The sooner the better. Don't make the mistake of putting off user testing until just prior to launch. By then it is too late or too expensive to fix things. Instead, make simple user testing a part of the development process from day one. You will end up with a more usable site for less money in the long run.*

- *Get a user, any user. Much is made of "representative samples" in psychological research—and for good reason. But don't assume that you can't learn about your site's usability unless you have a "typical" user on hand. Results of human performance research are on the whole more general than those from other types of psychological testing.*

- *Do it again, and again. User testing is a process of trial and error. In order to get rid of the errors, you need a lot of trials. Simple, consistent testing throughout development is much more valuable than a single, large, complex study at the end.*

Other Tools

These relatively simple tools can be used as a "first pass" to weed out task-critical or pervasive problems that would otherwise mask more subtle challenges discovered on the "second pass" with formal usability testing.

- *Cognitive walk-through. Here, human performance specialists break down specific tasks into essential cognitive components in an attempt to determine how usable the site will be for first-time or inexperienced users. This should be part of the development process.*

- *Usability audit. This method involves having usability experts examine an existing site and suggest improvements based on accepted usability guidelines. This can be a very cost-effective way to begin the process of improving site usability.*

- *Focus groups. This usually entails assembling a group of people who have used the site or a prototype, or who have simply seen mock-ups or schematics; then questioning them about it. Focus Groups can give a general sampling of user opinions, but are not a substitute for actual user testing.*

- *Log file analysis. Server log files can provide important clues about traffic patterns, popular entrance and exit pages and link visibility.*

From Foraker Design www.foraker.com
To find usability professionals, visit www.upassoc.org.

USER PROFILE:
LEARNER

WHAT GOALS DO LEARNERS HAVE?

- [] To be educated, either on a specific topic or general category of interest
- [] To spend their time productively and efficiently while online
- [] To find credible research-oriented sites

Karen S. Teitelbaum

Demographics: Female, 49, single, suburban, upper-middle class

Occupation: Management consultant

Personality traits: Energetic, optimistic, purposeful

Online habits and behaviors: "I'm on about two hours per week, and I log on from both work and home. I have a cable modem in the office, and a dial-up connection at home."

Web history: "I have assistants who do most of the research, so until my diagnosis with breast cancer, I didn't use the Web. The diagnosis drove me online."

Favorite Web sites: Salon.com, Google and Yahoo

Usability pet peeves: Bad navigation, bad writing, pop-up windows, required registration on free sites

How do you search? "I will use the search field but I'm often disappointed with the results."

What are your typical online goals? "I use the Web when I need it. I don't have time to play around with it. I'm very impatient. If something downloads slowly, I go nuts. Lots of sites are crammed with so much stuff that you can't see what you want. I like a good, clean design. I want to be able to move around a site, go back and forth. I need clear directions about what to do"

LEARNERS

What is learning? A philosophical question, perhaps, but also relevant when we think about the Web because many different activities are placed under the heading of "learning": researching, information-gathering, online classes and more.

There is a lot to learn online, and all kinds of people seeking information and knowledge. Learners may include a senior citizen looking for information about breast cancer at Breastcancer.org; a business owner or marketing manager reading the day's news on the *Wall Street Journal Online* before starting his or her day; a retired man learning about the origins of man at Becominghuman.org; or a teacher looking for a lesson plan at Exploremath.com.

Each of these learners has a different goal and a different mindset when he or she logs on to a Web site, but they all have in common a desire to find new information. The sites they visit must make that easy for them to do.

Information-seekers are proactive Internet users, task-driven like many on the Web, but willing to linger longer on a site or page where they find something of interest. Users in research mode use the Internet like an encyclopedia, employing search engines to scour online databases, news and information sites, and anything else related to their research subject, whether it's oriented toward commerce, entertainment or education.

"Information-seekers are more likely to enter a term into a Web-wide search engine or drill-down via a complex taxonomy system than those in other usage modes," writes usability engineer Josh Fruhlinger in the December 2001 *Web Techniques* magazine. "These users ignore links that don't relate to their subjective search. However, they're most likely to follow related links that lead them to another site. They're also extremely dependent on good front- and back-end design; if they encounter long database query times and poorly designed user interfaces, they leave and look elsewhere."

BREASTCANCER.ORG

Navigation Redesign

Organization type: a nonprofit educational site about breast cancer

Web site address:

www.breastcancer.org

Designer: Derek Olson, Foraker Design (Valhalla, NY)

<THE ORGANIZATION>

Breastcancer.org is a Web-based nonprofit organization dedicated to providing information and community to those touched by the disease. The company was founded by Marisa Weiss, M.D., a radiation oncologist specializing in breast cancer with an active practice in the Philadelphia region.

<THE SITE>

When a woman is diagnosed with breast cancer, there are many questions that arise and decisions that must be made quickly. According to Karen Teitelbaum, a typical user of this site, "If you type breast cancer into a search engine, you find sites with lots of sharing and support, but it doesn't give you what you need: an explanation of what you have. This site is different because it contains critical information that women need, covering every single stage. There are medical sections, with articles about how to understand your pathology report, and personal sections, with little things like how to find a wig place."

"We also take care of people," says Weiss, "so the look and feel has to be warm, inviting, reassuring and comforting. At the same time, it must communicate the fact that it's a medically oriented site made up of experts in the field with high-level credibility. So we chose a design that doesn't look like a medical

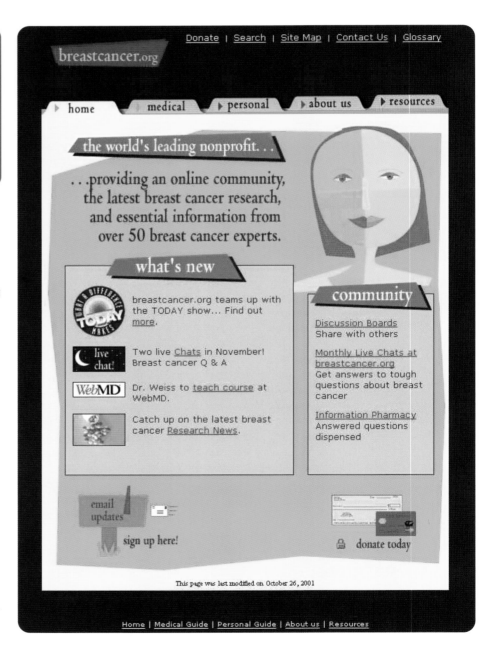

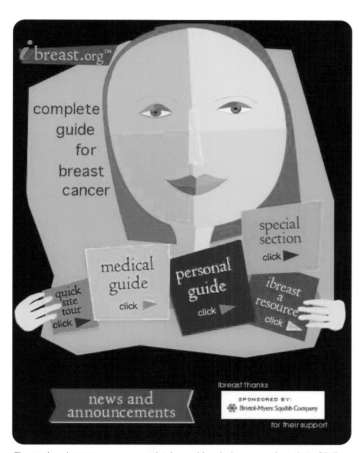

The previous homepage was a completely graphic splash page, a giant shot of Polly, a Picasso-esque woman who doubles as the logo, holding cards in her hands which represent the different sections of the site. At 51K, and mostly large files making up the image, it took 45 seconds to load over dial up connection—way too long. Also, the fact that there was no text on the homepage meant it was a poor performer in the search engines, a big problem for such an information-rich site.

textbook, but conveys the impression that we're tackling tough medical issues without being conventional and stuffy."

The challenge for Dr. Weiss and the team at Foraker Design was to welcome visitors into the site and let them know what's available without overwhelming them.

<THE USERS, THEIR GOALS AND THEIR TASKS>

Visitors to the site are generally older women who either have breast cancer or know someone who does. Most are from the United States, but there is also a small international contingent from the United Kingdom, Israel and Australia. Their main tasks on Breastcancer.org are to learn about the disease and to interact with other visitors in an effort to get help, information, resources and support.

Because the topic is a sensitive one and many users are anxious when they come to the site, it is especially important that their experience be easy and frustration-free—a real challenge when the users are generally older and not very Web-savvy.

From e-mail messages to the site and other contact with users, Foraker was able to deduce that visitors are indeed on the low-tech end of the spectrum, an older cross-section of people who didn't grow up with computers, and for whom the Web is a foreign space. Many lack familiarity with conventions such as the *Back* button; others even have trouble finding basic information displayed right in front of them.

Says Derek Olson, lead designer on the project, "Some users respond to monthly e-mail updates as if they were personal messages, thanking the site for sending them. This is actually quite touching, but makes you realize that they don't necessarily understand how it all works."

Log files revealed that while over half the users have up-to-date browsers, a significant percentage still uses browsers from as early as 1997. Because most of the site's e-mail messages originated from dial-up ISPs, designers assumed that the vast majority of their users had a slow-speed connection. They had to think twice about how fancy to make the Web site.

<GOALS OF THE REDESIGN>

Foraker's revision was actually the third iteration of the site. The original site, ibreast.com, had a different look, as well as different branding and content.

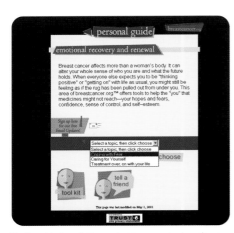

On the old site, all the navigation was via drop-down menus, which meant you only could see the level you were on. It took too many clicks to get anywhere and most visitors could not find essential content.

The second iteration carried the name change (to Breastcancer.org) and launched in the fall of 2000. It was a beautiful but unusable site. Cutesy headings proved to be irrelevant and meaningless to users, while ill-considered navigation devices made it nearly impossible for inexperienced visitors to use the site. For example, the Toolkit, a cute little resource box that opened a new pop-up window, cut down on page clutter but was disastrous for usability. Putting all resources in one place and out of the way is not such a great idea if no one can find them.

The objective of the newest version was to retain the branding but revise the layout, navigation and graphics. Olson trimmed about a third of the fat off the Polly image by optimizing the graphics and slicing the images into "bite-sized" pieces, which preserved quality while increasing efficiency. The new version, which is no longer simply a splash page, weighs in at 37K, with the largest single graphic file at 6K. It takes fifteen to twenty seconds to download on a dial-up connection.

Additional graphics are employed only when they are useful, as meaningful content in the form of photographs of cancer-related products, drawings of the body, or diagrams of tumor sizes. Graphics are also used to provide familiar visual cues, such as the folder tabs that were chosen for the interface because they are similar to those used by Amazon and AOL, and thus are familiar to most visitors. The tabs allow all sections of the site to be consistently accessible, and offer visual cues to facilitate movement from one section to another.

On the original design, links and labels were not clearly differentiated. Older users may understand text links, but they may not know that graphics can also be links. Designers should not assume that everyone will auto-matically mouse-over a graphic to see if it really is a link.

On the new site, text links at the bottom of the home and section pages offer another way into each tabbed section in case someone doesn't use the graphics or they do not load properly. As a rule, text links are also helpful for any user who has scrolled all the way down the page and doesn't want to bother scrolling back up. This little bit of text also makes it easier for search engine spiders and bots to find and index the site, increasing ranking and thereby affecting usability.

Because of the relatively older target audience of this site, large, legible type and adequate spacing between lines were priorities, creating a major challenge to the site's aesthetic appeal. Among other things, large type may require more scrolling, not only vertically but also from side to side, depending on the user's operating system, browser and screen resolution.

"We wanted the text to be flexible according to a user's needs," says Olson. "This means that the font size should be readable across most browsers and platforms by default, but we must also allow users to increase the font size using their browser settings." For this reason, Foraker specified relative font sizes, instead of absolute pixel values. The latter is attractive to designers because it allows greater control over site aesthetics, but it constrains users from altering type sizes to meet their own needs.

<NAVIGATION>

The old site was beautiful and colorful, but it was very easy to get lost in. There were no good indicators of where you were, or how you might get back to that spot in the future. Moreover, there was no site map.

The old site was divided into three main levels: sections, topics and subtopics. The old

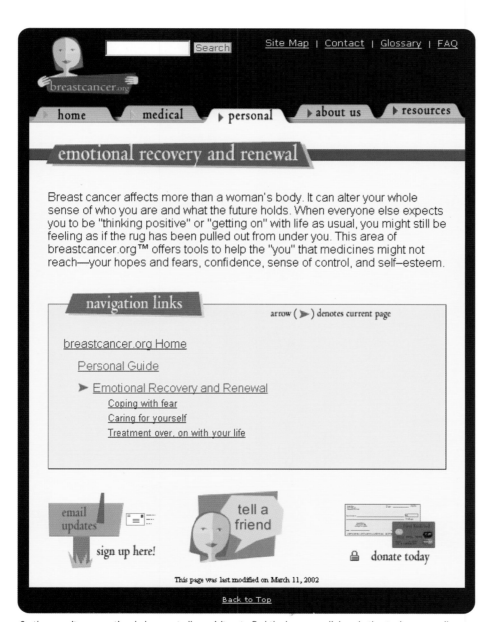

section page was heavy on graphics, providing little useful information about where a visitor ought to go. The only other access to pages deeper in the site was located on a pull-down menu.

Because the site is so deep—almost five hundred pages—Foraker had to devise a clear yet concise navigation system to help people find their way through it. Ditching the pull-down menus, he placed a consistently colored box, labeled Navigation Links, at the same location within each level. Links to the other content areas, the homepage and site tools are now more easily spotted.

If a user needs additional instruction, alt text boxes offer extensive explanations—even directions about how to use each element, whether text or graphic. On this page, mousing over the logo link in the upper-left corner of the screen triggers a box that describes what the link does.

On the new site, conventional placement allows visitors to find the homepage link and other tools more easily. Blue hypertext provides users with an obvious navigation scheme and permits them to jump from one section to another (e.g. to Medical from within Personal). Page indications help users remember where they are.

<TYPOGRAPHY>

Content pages on this site use large blocks of text to relay information. Because reading from a monitor is more difficult for older people than reading from paper, size had to be fairly large and the font style very clear.

However, specifying relative font sizes instead of pixel value leads to problems when text is surrounded by graphics that are stacked up in a table.

On these pages, rather than selecting absolute pixel value, Foraker specified relative sizes in Arial and Helvetica fonts. This allows users to increase type sizes on their own monitors by adjusting browser settings.

This shot of a recent version of the homepage (as seen on a Windows 2000 PC in Internet Explorer 5.5) demonstrates some of the difficulties encountered when users try to adjust the type size. If the text gets too big, it can break the table and make the page's alignment look unbalanced.

This is the same code viewed on Windows 2000 in Netscape 6.1. In this version, some of the graphics do not match up properly because there is too much space between the lines.

The same page as viewed on a Macintosh OS 8.6, with Netscape 4.7. This is another illustration of the differences between browsers. Olson built in a buffer zone to accommodate large text, but too much of a buffer looks funny in browsers with relatively small text.

POP-UPS

"For this user group, pop-ups are best used as closet space," says Olson. "You wouldn't put the light switch for your bedroom in the closet, but you might put your golf clubs in there. Pop-ups are useful when you don't necessarily need a whole new room but you want to keep things out of the way."

Olson opted to use pop-ups for functions that weren't essential to the site, such as Tell a friend and registering for e-mail updates. It made sense that a user would not want to lose their place in the content just because they had the impulse to tell a friend about it.

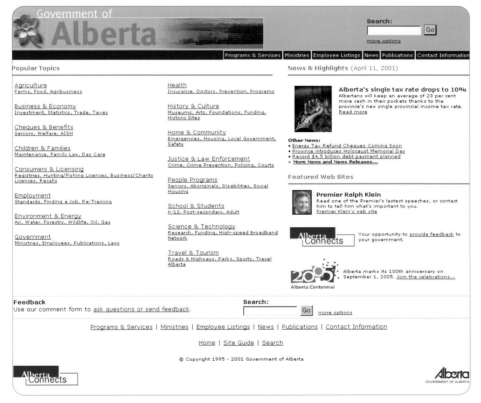

Site makeover

Institution type: Provincial government of Alberta, Canada

Web site address: www.gov.ab.ca

Designers: In-house Web team at the Alberta Public Affairs Bureau, plus Jess McMullin, freelance User Experience Architect

<THE INSTITUTION>

The Public Affairs Bureau of the Government of Alberta, Canada is responsible for distributing information about the government, its programs, and its services for the public.

<THE SITE>

The Government of Alberta Web site is a comprehensive site that seeks to satisfy a lot of people a lot of the time. It provides information about services and programs offered by the province, connects visitors to the ministries and organizations that make up the Government of Alberta, and offers links to resources for further information.

<THE USERS, THEIR GOALS AND THEIR TASKS>

Unlike a private or public corporation, the Government of Alberta is obligated to meet the needs of all citizens and stakeholders.

The main audience for this Web site, then, is all Albertans, plus anyone outside Alberta who needs information about the province. That, of course, is a very diverse audience.

User research—which included an independent survey of Alberta Internet users, staff roundtables, a review of search logs and traffic statistics, as well as user comments received through e-mail—indicated these specific user demands:

- That the organization of the information be intuitive
- That the navigation be simple
- That the bureaucracy be hidden
- That the language be plain and understandable

According to Gene Smith, Manager of Internet Services for the Alberta Public Affairs Bureau, the goal was to design a site that would work for novice users with less than one year of Internet experience. However, they found that people with less than a year on the Internet still have a wide range of abilities. "We now measure a user's probable Internet and computer skills by the number of hours online per week rather than length of experience," says Smith.

The team has developed four profiles of typical users or personas:

Working-class Guy: In his mid-forties, he is a technical college grad who makes less than $50,000 a year and doesn't know much about the government. He wants to feel in control and is very goal-directed. When online, he wants to get the information he needs and get out.

Soccer Mom: She is in her mid-thirties, is married and has kids. A college graduate, she is employed part-time and is active in her community. She feels pressed for time, but is concerned about people issues. She has moderate computer skills.

Active Senior: This retired woman is in her mid sixties. She is a college graduate who likes to travel. She is interested in politics and has some understanding of government. Financial matters are a concern. She has limited computer skills but is willing to explore Web sites, and uses e-mail to keep in touch with family.

Small Business Owner: In his late twenties, he is a college graduate who makes over $50,000 a year. He prefers the government to be hands-off and is concerned about taxes and economic development. He is a frequent Internet user with good computer skills.

Given the wide, diverse audience of Albertans, the site was designed for the current standard: 800 x 600 screen resolution, viewable using Microsoft Internet Explorer 5.0/Windows 95/98, and each page template was designed to be under 50K (including images). Hard data from surveys and log files showed that ninety percent of the site's users have IE 5 or later, although the site still functions in Netscape Navigator 3. The team also made sure the site would work without JavaScript or cascading stylesheet-enabled browsers.

Most visitors to the site are interested in what the government can do for them on a variety of topics, and some typical user tasks might include:

- Looking for information about legislation, economic indicators, and budget impacts
- Finding out about the public healthcare system
- Tracking down a government check that didn't arrive on time
- Contacting a government employee
- Renewing a driver's license
- Contacting the premier (provincial governor) about an issue

<GOALS OF THE REDESIGN>

The designers of the original site made an all-too-common mistake—one often made by institutional teams that don't remember to look at tasks from their visitor's perspective. The information architecture of the site was organization-driven, meaning that the information was organized according to the hierarchy of the government. This system required users to understand how the government works in order to find what they were looking for. So, for example, if you were looking for information on benefits for the disabled, you'd have to determine which ministry handled the Assured Income for the Severely Handicapped program (not always obvious) before you could get any answers.

Also, each ministry had its own Web site; so to find services, visitors would go first to a listing of ministries, then click again to link to the ministry's Web site. Each of these sites looked different from the main Alberta site, and this was confusing to visitors. A primary goal of the site's makeover team was to integrate all information into one unified site so as not to confuse visitors.

But the biggest problem with the site was that the content it offered wasn't what visitors were looking for. News and announcements were the site's most prominent features. Because the site was created and managed by the government communications department, that's what they have most readily available.

Although the government's user base is certainly interested in the announcements, Albertans at large are more interested in what the government can do for them. So this iteration of the site minimized space for news and brought more product and service information to the surface.

This version also refreshed the visual design. Says Smith, "When you look at a site every day, you want it to be visually interesting so you don't get bored. But in user testing, the message we got was to keep it simple. They said, 'Give me what I want. Eliminate the detail. And give me an escape hatch in case I can't find what I'm looking for.'"

<NAVIGATION>

To aid in the user's search for specific information, the site now offers a variety of navigation aids.

A search option is important for an information-rich site like this one. And although the Web team's research shows that it is not the most effective way to locate information, users want it. Focus groups indicated that focus groups liked to see the search box right on the main page. Smith thinks it's for comfort; that if users can't find a good link they can always click on Search.

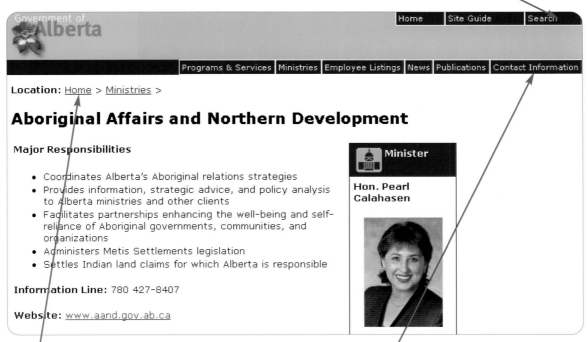

The breadcrumb trail, located below the header in the upper-left corner of each content page, serves a dual purpose. First, it reveals the site's structure to visitors and orients them within the site; second, it helps citizens understand the relationship of entities within government by showing how each ministry fits into the bigger picture.

The dark blue global navigation bar just below the header is consistent throughout the site, providing links to the main content areas, and directing people to basic government information.

Because this site is an information hub— but the Public Affairs Bureau doesn't control all the information being presented—the Web team decided to provide clues and hints to keep everything clear. For example, links to sites not related to the government are indicated with a simple "off-site." At the top of lower level content pages, a mini-table of contents helps users avoid unnecessary scrolling by providing in-page or anchor links to other parts of the page to show users what's available below the fold. The template for second-level pages is also clear and con-

sistent: the blue header and logo shrink a bit and the upper-right corner houses the site's toolbar: home, site guide and search. The left column holds a content box with important phone numbers or other relevant information; the middle column features the main content, and the right column holds related links and other resources.

To stay in touch with users' needs, Smith reviews the site's search engine logs every few months for popular query terms. For example, at one point he noticed that the terms *jobs* and *employment* represented

almost one percent of all searches—nearly three hundred queries in one seven-day sample. In response, a link to the government job listings was placed on the homepage with a fairly prominent graphic that said Jobs. Four months later, *jobs* and *employment* had dropped to 0.3 percent of searches. "It's not conclusive," says Smith, "but I think it shows that designing the homepage to offer what people are actually looking for can be effective."

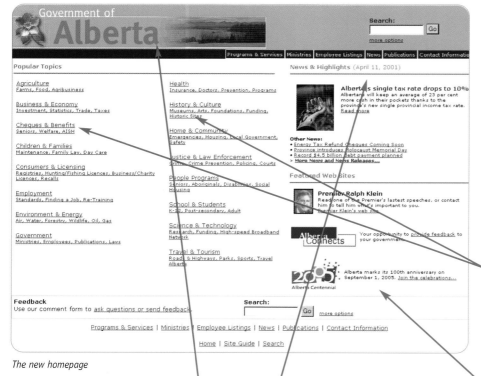

The new homepage

The old homepage

The topic listings that make up two left hand columns (and the majority of the screen) present text links to government information in easy-to-understand categories so Albertans who have had little experience with government can easily find what they need. Each topic listing includes a title and a few descriptive keywords to help users understand the scope of the topic.

Important changes include the replacement of the yellow header with a blue header, a professionally designed logo and new type treatment.

The news is less prominent, but still above the fold in the right column.

Dropping the right-hand navigation column allowed the entire page width to be devoted to content.

EXPLOREMATH

ExploreMath.com

activities :: lesson plans :: forum :: join :: login
▶ find course pages
● Math Headline News - Global news items focusing on math - View Latest News

an interactive learning experience

about
site map
site tour
intro movie

help
press & awards

newsletter
subscribe
[enter email address] go

also visit:
ExploreScience

Free Course
Web Pages ...

Easy to maintain
web pages for
all your courses.

Learn More!

▶ **The web's finest math activities just got better!**

Introducing ExploreMath Lesson Plans

Developed by members of the ExploreMath community, our lesson plans provide strategies for educators to introduce ExploreMath's unique multimedia activities into the mathematics classroom, lab, or distance learning curricula. View lesson plans

▶ **Explore our award winning math activities:**

view a sample (no plugin) | go to activities | get shockwave plugin

ExploreMath.com in action:

▶ **Online Student Attention**

Online mathematics teaching and learning is expanding quickly. School districts, colleges and universities are offering a variety of online components, ranging from simple listings of links to online resources, to online modules that supplement classroom teaching, partially online courses, and fully online courses.
Read more

▶ **The Intermediate Value Theorem**

"Suppose that your car has a thermometer on the side mirror. You leave school and the temperature reads 70°. When you get home the temperature reads 60°. Does there have to be a point along the road that is exactly 65°?"

Find out in this months featured lesson.
Read more

Math in the News

▶ **Euler's Homework**
Note: Link will open in a new window

"Even the best and most prolific of mathematicians have had to do homework assignments. Famed Swiss mathematician Leonhard Euler (1707–1783) was no exception." Full story
(Note: Link will open in a new window.)

View more math news stories.

▶ Highly interactive math activities for students and educators.

● activities by category

Points in the plane
Lines/Linear equations
Quadratics/polynomials
Systems
Inequalities
Conic sections
Exponentials/logarithms
Trigonometry
Complex Numbers
Absolute value
Reflections
Probability
Full Listing

 X

Usability makeover

Company type: Online educational publisher

Web site address:
www.exploremath.com

Designers: In-house team led by Edward Cossette, Director of Visual Design

<THE COMPANY>

ExploreLearning is an online educational publisher that works with middle school, high school and college educators to develop interactive learning tools and content for Web-based teaching and learning. They publish other interactive learning sites, including ExploreScience.

<THE SITE>

The ExploreMath.com team of educators and technicians believes the real power of the Internet lies in its ability to bring educators and students together in new ways to meet instructional needs and harness creativity. The site they created in 1999 (and have been revising ever since) offers highly interactive mathematics activities for students and educators, in addition to curriculum ideas, lesson plans, teachers' guides, and links to related material.

<THE USERS, THEIR GOALS AND THEIR TASKS>

While the material that makes up Exploremath.com is obviously for math students, the site's target audience is teachers, from the middle school level through college.

One thing the Web design team knows for sure about their users is that they don't have much control over the equipment they use. As a rule, teachers' technical resources are a few cycles behind those of other users because school budget constraints keep older machines in service for many years. For example, ExploreMath.com's in-house Web team can tell from server files that as many as 17% of their users still use Netscape Navigator 4, which was released in June 1997.

Educated assumptions that flow from this information include the use of low-resolution monitors at 640 x 480. And although the site is designed for a baseline dial-up connection speed of 56K, the site is accessible at 14.4K, just to be safe. (This also takes international users into account.)

Many on the ExploreLearning team started out as teachers themselves and are acutely aware of teachers' needs. Recent data suggests that forty percent of teachers are nearing retirement, so a considerable effort is made to support a user base that is older and didn't have the benefit of growing up with computers.

It is also important to consider the environment in which teachers use the site:

classrooms, where they are often trying to do a demonstration while projecting the site onto a screen, not to mention dealing with students whose main interest may not be algebra. The Web team knew they must keep things really simple, because these teachers wouldn't have the time to learn new navigation.

<GOALS OF THE REDESIGN>

In the more than two years since its inception, the Explore Learning Web team has learned a lot about teachers' priorities and needs. "At first," says Edward Cossette, Director of Visual Design, "we thought the two main functions would be to use both the *Gizmos* (the interactive activities) and the administration tools, such as the free teacher homepage. However, ninety-eight percent of users come for the *Gizmos*; there is very little interest in the administrative features. They just don't need that from us."

At first glance, it could seem like an obvious usability no-no to design an interactive multimedia site for a group of older, low-tech users. The only reason the team could attempt such a design in the first place is that the content is so highly valued by these users. Also, the site goes to great lengths to bridge the technology gap with usable design. It focuses on easy-to-read text and provides help wherever possible.

What makes this site easy to navigate is the consistency and variety of the navigation aids. "We always try to give people a second or third chance to understand if they didn't get it on their first look. And we go out of our way to explain things because teachers don't have time, and because it is a core value of the company. We're constantly learning and trying to pass on what we learn."

The header at the top of the page is a consistent global navigation element, located in the same place on every page.

Text links at the bottom of the homepage further describe what can be found in each section.

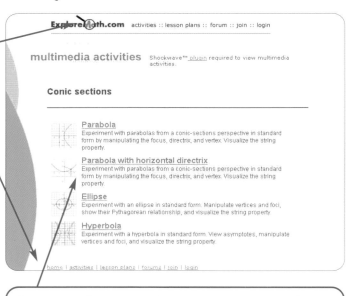

This layout is a basic one; mostly text to conserve bandwidth. The design challenge, of course, is to make a page of text look anything but boring. The small thumbnail images that represent each activity add a little eye candy, and the colorful shapes in the background are in CSS which, once loaded, never need reloading. Cossette says the next iteration of the site will consist entirely of CSS, which will allow the page to be resized according to each visitor's screen resolution. This will also replace table-spaced layouts and help to control positioning; the page will assemble itself according to whatever browser the user is running.

<OLD GIZMOS DESIGN VS. NEW GIZMOS DESIGN>

The Gizmos page was redesigned for better usability. In order to use the Gizmos, users must have Macromedia's Shockwave plug in. Usually a site that requires it will ask the user whether they have it, or offer a user-based, active choice of how to view the site. But people don't always know off the top of their head whether they have the software needed, and it's unlikely these teachers would, since this equipment doesn't even belong to them. So Exploremath.com dedicates an entire page to this question in order to make it easy for the user to figure out whether they have or need the plug in. The text says, "If you see the Shockwave animation below, you are ready to begin exploring the multimedia activities. If you don't see the image, you will be prompted to download the plug-in and/or you may read the instructions below."

The Web team has created a visually pleasing yet very light-weight site. The average page requires 10K, excluding the Gizmos, which may require up to 20K. The entire page only requires 30K, while the current average on the Web (without any multimedia) is 70K.

According to Cossette, the next iteration will have even fewer graphics. The current header uses GIF-formatted files to create changing images for the global navigation links, a process that requires considerable bandwidth. In the new version, similar effects will be achieved through the use of cascading stylesheets. This process employs the user's own browser to change colors or other attributes when the user mouses-over an image, so the effect of multiple images can be achieved even with less sophisticated equipment and narrower bandwidth.

The tool bar was distracting users by the number and placement of the options it offered. To prevent the user from clicking on things that are not part of the actual teaching/learning aspect of the Gizmos, the tools that affect the Gizmos directly were separated out from the meta-controls (or administrative tools) not associated with the learner outcome.

Cossette applied a border, via CSS, around the entire Gizmos area to make it stand out, visually cuing the user that it's a distinct, special element on the page. In addition, a distinct header was added.

In an attempt to visually cue the user to click the checkboxes and the thumbs on the sliders, they are created in 3-D shapes to visually suggest that it's something to "grab" and move. Also they kept the checkboxes in gray scale rather than color so as to keep color cues specifically related to the math, lines and equations.

THE WALL STREET JOURNAL ONLINE

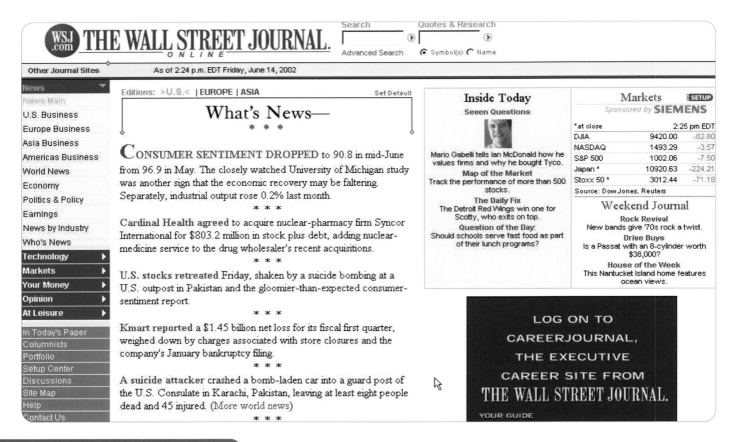

\<THE COMPANY\>

The *Dow Jones Wall Street Journal* publishes a daily business newspaper, among other information products.

\<THE SITE\>

Since its launch in 1996, the original version of *The Wall Street Journal Online* has been a paid subscription publication and a close copy of its print counterpart, all the way down to the trademark miniature diamonds. Subscribers to both could easily navigate between the online and print versions without feeling too lost. But in early 2000 Neil Budde began a two-year redesign process, gathering a team of up to a hundred experts in a range of areas, including IBM global services employees, Dow Jones employees, and outside consultants.

Reading from a computer screen is different from reading a newspaper or magazine. When we read a newspaper on a bus, in a coffee shop, or in an airport terminal, we usually aren't multi-tasking, so fewer distractions are tolerated. In contrast, online readers are catching up with their news between phone calls, e-mail, or conversations with colleagues. Competition for their attention includes all the daily activities in and around the user's computer, so online news needs to be instantly accessible and easily skimmed.

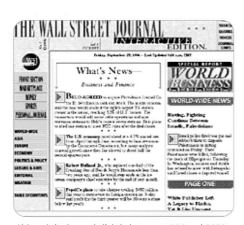

Although it changed slightly between 1996 and 2002, the homepage of the original site remained largely the same as the front page of the print edition: three narrow columns that scrolled down, a left navigation bar with labels that matched the sections of the print edition, the major market indexes and a couple of ads. Everyone who visited the site saw the same homepage.

\<THE USERS, THEIR GOALS AND THEIR TASKS\>

The main users of *The Wall Street Journal Online* are business consumers, most of whom log on from the workplace. Those who log on from work tend to have higher speed connections than those who log on from home or elsewhere. They also tend to have less time. Both of these facts affect the visual design of the site.

Although high-speed connections are available to the majority of its users, *WSJ Online* was designed for a baseline connection speed of 56.6K to accommodate international users, who make up ten percent of the site's visitors. It is designed for a minimum screen resolution of 800 x 600 but has scalable pages that can expand to fill wider screens if necessary.

How Web-savvy are the readers of *WSJ Online*? Budde says it's a mix. For the most part, though, the questions that come in over his e-mail transom (he publicizes an e-mail address on the site to which people can send him feedback directly) show a certain level of intelligence about the Web. Moreover, many users personalize the site for their own preferences, which requires a certain level of comfort with the Web and a commitment to the site.

By the end of 2001, the site had 626,000 paying subscribers. From among them, the design team identified four user personas:

The Print Subscriber of WSJ who comes to the site to supplement the print edition with the material available online. One-third of the site's subscribers get both the print and online versions. These readers log on after they read a story to save it, print it out, e-mail it to someone, or get additional information. They also often use the site for archival purposes, to find something from a previous issue if the print edition has already been thrown away.

The Traditional News Reader who has transferred over from print, logging on early in the day to get his fill of significant news.

The Researcher comes to check out companies and read articles from the archives.

The Investor comes to track stocks and news about companies before investing.

\<GOALS OF THE REDESIGN\>

With so many different users coming to the site for different purposes, how do you design a functionality to meet all of their needs? That was the biggest challenge for Budde's team. But they couldn't answer that question before answering this one: What does WSJ Online stand for, and what attracts the people who come to it?

Usage data indicated that visitors wanted primarily to access news content. So instead of improving their storytelling with multi-media, or upgrading the software application for stock tracking, designers focused on making the news content more accessible and customizable.

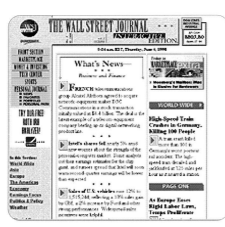

Another change is the scalable screen, which automatically expands to fit the full width of a user's browser window, no matter what screen resolution has been chosen. This eliminates the empty strip of white down the right side (pictured above) on screen resolutions of 1024 x 768. With 600 x 800 pixels, it's the difference between seeing five versus six news summaries.

The new look of *WSJ Online* is designed to help users get the news they need faster and more easily. Every element of the design has been rethought and revised with an eye toward making each page more consistent, more informational, faster to load and easier to read. (In fact, the print edition, which was also redesigned around the same time, published strikingly similar goals.)

In the previous version, the personalization area had more functionality but was located away from the main news, so not only did users have to go somewhere else to do it, but the process was extremely complicated. The new design not only puts access to the personalized features all in one place; it anchors them to the homepage. Users can turn the portfolio off, and then easily restore it again—all without learning how. The process is easily accessible, and simply explained, which seems to be an improvement; 70,000 people changed their personalization settings during the first two weeks after the new site began running.

The site offers so much content and is visited by so many different people, each with their own perspective, priorities and interests, that "We couldn't satisfy everyone by making choices for them," says Budde.

"So we give them control over entry points into the content. Not only can they personalize the content they view; they can also customize the layout of the pages. So instead of producing a flat HTML page that every visitor sees, each page is now dynamically generated to meet individual needs."

Personalization makes delivery of the homepage more complicated, certainly, but giving that much control to the user is designed to increase the amount of time they spend on the site, as well as the number of visits they make. The effort of personalizing content and layout requires a commitment that users wouldn't make if they didn't intend to use the site regularly. "Business consumers' needs are more focused and are often better suited to things like personalization. Being personalized can help a site forge a deeper relationship with the subscriber," says Budde. "It drives traffic and supports higher renewal rates."

WSJ Online doesn't give away all its control, of course. Just like in the print edition, the left column, entitled *What's News*, still offers the perspective of the *Journal's* editors, who put the news into context. *Page One*, just below, is also written from an editor's point of view.

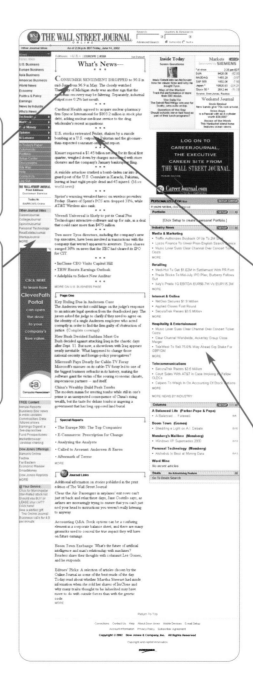

On the newly redesigned *WSJ Online,* every design element caters to easily accessible news. The headlines are shorter and the pages are wider and scalable (they expand to the size of each user's window)—all to reduce the need for scrolling and to increase readability.

Another new element is the left navigation bar, which now more compactly and clearly delineates *WSJ Online's* structure. The user can click on any name in the bar to move among the site's main sections and pages. For consistency, key links are positioned in the same spot on every page. Links to site tools, such as *Portfolio, Setup Center, Help* and *Contact Us*, are placed below the main navigation bar, also on the left, and as text links at the bottom of every page. An orange color cue indicates the page the user is viewing.

In the early days of *WSJ Online*, text links weren't as conventional and widely understood as they are now, so in the What's News column on the homepage, none of the text was clickable; the familiar diamond icons were used as links to read more of the article. Text links are now the convention, so the diamonds have been discarded and more content is now accessed by clicking on the blue text links.

Personalization is common to many content-oriented sites, but at *WSJ Online*, users can arrange the layout of their personalized homepage to make it more convenient. Easy-to-use tools at page right allow users to move subject areas up or down. And if there's a subject they don't want to see, they can easily hide it.

Original Site

Company type: Research organization

Web site address:

www.becominghuman.org

Designers: Bart Marable, Creative Director, Terra Incognita Interactive Productions (Baton Rouge, Louisiana) www.terraincognita.com

<THE ORGANIZATION>

The Institute of Human Origins is a nonprofit, multi-disciplinary research organization affiliated with Arizona State University, dedicated to the recovery and analysis of the fossil evidence for human evolution.

<THE SITE>

The goal of the site—aside from the minor task of teaching six million years' worth of history—is to provide a compelling learning experience on the vast subject of human evolution to a diverse audience. The site consists of a documentary, interactive lessons for children and adults, and a reference section for more information on the subject.

<THE USERS, THEIR GOALS AND THEIR TASKS>

Because the site caters to a variety of visitors (the designers are careful not to call them "users"), it endeavors to meet the needs of different audiences in different ways while maintaining a unified structure.

Some visitors come to Becominghuman.org hoping to be led into an engaging and immersive experience; others use the site looking for quick references. Some come with a good working knowledge of paleontology, while others need a compelling introduction to the subject. The site gives its audience many choices for viewing or experiencing the site, from passive to highly interactive.

Employing the user-centered design method of identifying personas, Terra Incognita developed imaginary profiles for four different visitors:

Mary, a high school student, spends two hours online daily, and is comfortable with technology and is willing to immerse herself in the site.

Max, a 35-year-old writer, is comfortable with technology and uses the computer as a tool. He is looking for resources and needs quick access to facts.

Jane, a 42-year-old teacher, is comfortable with technology but goes online only at home. She is preparing material for her class, so she needs quick, guided access and downloadable materials.

Bill, a 52-year-old pilot near retirement, is curious: an armchair traveler, good with the computer but not a sophisticated user of the Web. He's looking for an overview of the topic and a few resources.

Neither the design firm nor the client had hard data on these users, but they decided to build the site for the long haul. "If we're cutting edge in 2001, we'll be a standard in 2003," says Marable. So they decided to aim high in terms of technical requirements—using Flash in strategic areas of the site—while at the same time making most of the material accessible to the technically challenged. "We felt that in order to best tell the story, we had to move beyond the limitations of dial-up connections. But we didn't make the production so large as to be out of reach of higher-end dial-up visitors."

Visitors need a broadband connection to play the documentary, but can visit the exhibits without it. And everyone, no matter what their technical resources, can access the reference level, which is most usable because it contains text only.

<GOALS OF THE REDESIGN>

The main content box, which fits into an 800 x 600 window, is devoted to the three tiers of the program. Tier 1, the documentary, featured at the center of the screen, is the main destination on this site and is aimed at Mary, the high school student, and Bill, the armchair traveler. Tier 2, offered in navigation bars at the left, top and bottom, supports the documentary and is aimed at Jane, the teacher, and Max, the writer. Tier 3, The Learning Center, offers downloadable lesson plans, for visitors like Jane.

According to Bart Marable, Creative Director of Terra Incognita, "Usability is absolutely crucial to all of the projects we produce." The Terra Incognita team refined the architecture, navigation and design to create an experience that was both clear and compelling. They want their visitors to find the content they are looking for, but they also want to create an engaging, powerful and sometimes surprising experience that makes people want to learn more. "We call it a 'documentary experience' because it's more than simply a documentary film," says Marable. "This type of documentary encourages visitors to help direct their learning experience, much like a museum exhibit would."

One goal of the project was to create a seamless and integrated experience by crossing these horizontal tiers with vertical lines throughout. There are story lines that go from top to bottom of this experience pyramid. So, for example, if you're watching the section about paleontological digs on Tier 1, you can see related exhibits that explore a virtual dig at the Exhibit level on Tier 2, and if you want to learn more, you can go to the Reference level on Tier 3 for more Web sites on the topic.

Besides the graphics, which are beautiful, it's the site's navigation that stands out. It's an elegant combination of linear and nonlinear experiences. "We have a linear narrative spine where people can find context and orientation. But once visitors are oriented, they like the ability to increasingly direct their own experience. In our model, we offer suggestions for these departure points for those who want to follow them," says Marable.

On Tier 1, the experience is linear and time-based while a visitor is watching the program. ("Linear" is often considered the antithesis of what happens on the Web, but can be used online to increase exploration, as is being done here.)

On Tiers 2 and 3, the experience is non-linear in a way that Marable likens to riding a Gray Line Tour bus. "While you're on the bus, the guide is giving the tour, providing context and orientation, which is crucial. But when you see something you want to know more about, you can hop off, do a little exploration, then hop back on when you're done. Likewise, the documentary provides opportunities to jump off and explore deeper where a visitor's interests lead, until they want to come back and continue."

Visual prominence and more space are given to the richer, more dynamic exhibits as a way to guide visitors toward them. "Visual

magnets become landmarks," says Marable, "drawing visitors into zones of experience we want them to see."

Still, the navigation is not always obvious and requires some experimentation on the part of the visitor. Indeed, there is a learning curve that all visitors have to go through in order to get the full experience of the production. With that as a given, the Web team tried to make it as painless and fun as possible.

In telling the story of human origins, the visual vocabulary—color, type, textures, and other aesthetic choices—reflects a rich design legacy and is aimed at supporting the story. The rich visual vocabulary evokes classic images of archeological digs. For example, the borders that surround images look like old lithographs. The type used for the headlines is Whittingham, a new but very classic-looking typeface; the body text is rendered in sans serif Frutiger for legibility.

Tier 1: At the Program level, the documentary is intended to be very rich, dynamic and emotionally engaging—a compelling gateway experience to the rest of the content, for those who need an overview of the topic. It's a linear, "lean-back" experience, modeled on television. In fact, although it resembles a companion site to a documentary you might see on the Public Broadcasting System, there is no TV counterpart, and no video available. One reviewer called the site "the missing link between television and the Web." Macromedia also likes to use BecomingHuman.org as an example of the potential for Flash-based online experiences.

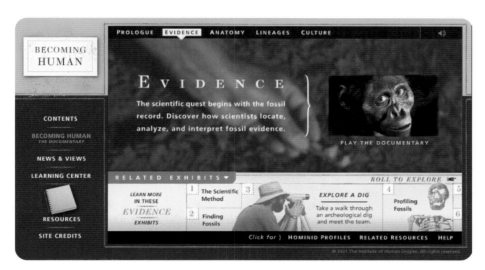

Tier 2: The Exhibit level is more hands-on. It offers text, photos, short interactive sections (for example, a visitor can click on "Explore a dig," where they can walk through a virtual archeological dig), and self-contained substories. This tier provides context and interactive storytelling, like a museum exhibit. Navigation isn't obvious, so there are directions (e.g. "Roll to explore") for how to make the bar scroll.

Tier 3: The Reference level provides reference information and resources: a reading list, a glossary, links to other Web sites. The purpose of this level is to extend the experience offline. It's actually the most interactive level because it requires the most action (to find one of the books, you must go to the library) and is a good springboard for further learning.

>>>>>

WHAT GOALS DO SHOPPERS HAVE?

- To acquire all the information they need before making a decision to purchase a product
- To complete transactions in a safe and simple environment

Leslie Kessler

Demographics: Female, 44, single/divorced

Occupation: Marketing Consultant

Personality traits: Genuine, compassionate, passionate

Online habits and behaviors: "I go online at least twice a day, for a total of about four to five hours a week. I have a dial-up connection."

Web history: I've been using the Internet for e-mail and information for five years.

Favorite Web sites: United.com, Amazon.com

Usability pet peeves: Complicated interfaces or navigation; banner ads, especially the ones that are disguised as problems or part of the site; bad search capabilities

How do you search? "I almost always use the search field first. I just don't have the patience."

What are your typical online goals? "I want to get in and get out with the information I need to answer a question about a product."

SHOPPERS

In the same way that finding information online can be broken down into a variety of activities, so too can shopping. At the very least, shopping involves browsing, selecting and purchasing, and each shopper may do any of these activities either online or offline.

Studies reveal that online shoppers don't shop exclusively online. These multi-channel shoppers use any means available to them—retail stores, catalogs and the Internet—to research and complete their purchases. In general, more women tend to be channel switchers than men. They cite price, selection and convenience as benefits of catalogs; speed and twenty-four hour availability for the Internet; and the ability to see and sample products for retail stores—all of which makes sense. Some people like to touch before they buy, but want to get as much information as possible from the Web to prepare for that magical moment. Others would rather do it all in their pajamas at midnight, when it's quiet, with no human contact, pointing and clicking all the way to the shopping cart—often with the company's catalog in hand.

Some online shoppers might include a new homeowner researching an appliance at ConsumerReports.org before heading to the store; a man buying jewelry for his wife's birthday at Ashford.com; a woman ordering pet toys and supplies on her lunch break at the Castor & Pollux Web site; an eager gardener anticipating spring at Smith & Hawken's Web site; an office manager ordering supplies on Staples.com.

Users in buying mode have a particular product in mind when they log onto an e-commerce site. They are aware and active. They have spent time researching the product and collecting opinions from those who already own it, visiting comparison shopping sites, and gathering information both online and offline. They will often follow links that facilitate their purchase or promise big discounts.

Online buyers depend on good user interfaces and are easily frustrated with poor shopping experiences. The computer interface is often the only contact the customer has with an e-commerce site, so good Web design is undoubtedly key to a site's success. Because shopping online is almost exclusively a visual experience, an e-commerce site needs to compensate for the missing sensory experience of tangibility through careful visual design and other multimedia features that create the illusion of dimensionality.

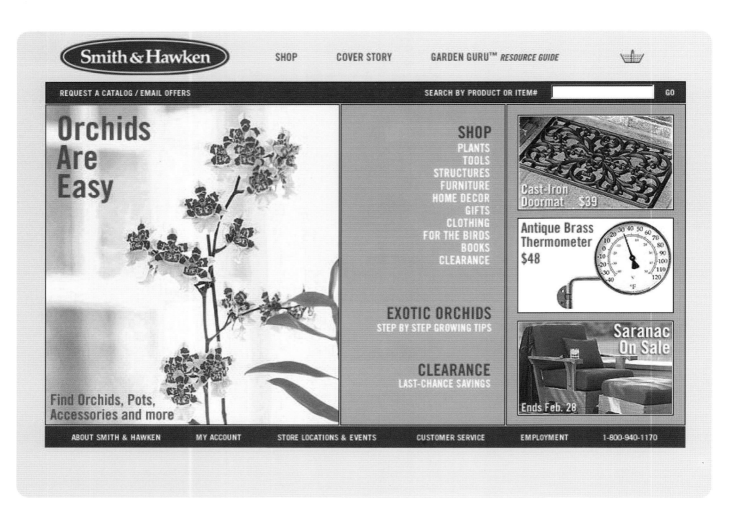

Site makeover

Company type: High-end gardening supply store

Web site address: www.smithandhawken.com

Designer: In-house designer Pete Graham, Web Site Coordinator

<THE COMPANY>

The success of Smith & Hawken, a "gourmet" gardening company that opened its first store in Mill Valley, California, in 1985, is based on the brand, which stands for high-quality products and garden expertise. The company also sells furniture, plants, garden ornaments and containers through a variety of channels: more than four dozen retail stores, a mail-order catalog and the Web site.

<THE SITE>

The goal of the online selling channel is to duplicate the experience of shopping in the store, a garden-inspired refuge where people often go to wander through misty aisles scented with potpourri and fragrant orchids. The challenge for the Web team was to bring that feeling of refuge or oasis online—a decidedly different medium—and to do it without using any technology, such as Macromedia Flash, that could hinder or intimidate people.

The e-commerce site is less seasonal than the print catalog; but in terms of selection, because everything in the catalog is offered online, a new batch of products must be prepared and uploaded to the site every time a new seasonal catalog comes out.

<THE USERS, THEIR GOALS AND THEIR TASKS>

Smith & Hawken customers are generally affluent, well-educated men and women: "busy people who enjoy shopping online as much as they do in the retail environment," says Lisa Bayne, who guides the in-house Web team. When they began, Smith & Hawken developers assumed their online buyers would be first-time computer users, so they worked hard to accommodate people who didn't have a lot of experience.

But Smith & Hawken soon discovered that their online customers were not necessarily the same as the retail or catalog customers. For example, over thirty percent more men shop online than through the other Smith & Hawken channels. At holiday season, there are more men ordering gifts online for moms and wives than buying through any other channel. The site is also tapping into the younger demographic of twenty- to forty-year-olds because more of them are online more regularly.

<GOALS OF THE REDESIGN>

The original site was split into two equal halves: commerce and content. You could shop online or you could learn about gardening. No individual products were featured on the original homepage, just a beauty shot which changed every few months to reflect the mood of the season. The informational content consisted of two monthly articles on the art and craft of gardening, a resource section with information on composting, orchids, and the like, and the *Garden Guru*®, a column answering questions posed by customers.

While Smith & Hawken received a lot of compliments, sales on the site didn't support this strategy. So the Web site was forced to move away from the richness and soft sell of the original homepage to one geared toward selling. "Much as many loved the feeling of refuge on the homepage," said Bayne, "we realized that we could make the site both more user-friendly and more profitable by layering on marketing content."

The redesigned site launched in mid-2001 with a new homepage that is clearly more e-commerce-oriented. The large rectangle on the left side of the homepage either replicates the cover of the current catalog to reinforce its impression on the consumer or presents a hero image of a bestselling product. On the right there are three smaller slots for individual products. Prices are provided for all products featured on the homepage, so that viewers are not forced to drill down to the product page as they had been on the previous site.

The old site was aesthetically pleasing and accomplished the goal of being a sensory-stimulating refuge, but sales figures were down.

The redesigned site scales back the articles to one per month and combines the rest into a single *Garden Guru®* Resource Guide without sacrificing content. Rather than put its resources into features with a limited life span, the Web team decided to deepen its offerings of how-to guides within the *Garden Guru®* section.

Bayne says it's a point of pride to maintain the look and feel of calm, beauty and warmth in the photos. "Our customers associate our brand with beautiful places and feelings of satisfaction and relaxation. Our hero images help translate that feeling to the Web. Now we feel that we've got the right balance between product marketing and garden expertise," says Bayne. "Our numbers prove that making the homepage more product-driven improves the response, yet the informational content is still there for customers who want to learn as they shop." The new Web site was validated by the Direct Marketing Association E-tailing group's rating as one of the top ten e-tailers in customer service (March 2002).

Usability expert Frank Spillers calls this site clean and uncluttered—quite a compliment for an e-commerce site, most of which are crammed with photos. But with so many products, how is this look accomplished?

Because aesthetics are crucial to this brand, the Smith & Hawken Web team doesn't take chances with font irregularities based on browser differences. For both product images and category names, GIFs are used instead of text. "We wanted to control the typeface, because you can't depend on users' browsers to actually deliver those fonts, so we force the issue and make them GIFs," says Bayne.

Photography is a major component of this e-commerce site. The Web team takes these relatively large images directly from the catalog on disk, then alters them for the Web. Photos are cropped to focus on the product and optimized for quick downloading.

Users can browse anonymously, load their baskets, take things out, visit the *Garden Guru®*, and come back to their baskets when they're ready. They don't have to register until checking out—a feature users love. Many people get nervous when asked to give personal details before browsing because, although it's improbable, some feel like they might accidentally purchase something. They are more comfortable browsing anonymously; later, when they decide to buy something, they'll happily give their information.

The shopping cart for the Smith & Hawken Web site is also very smooth, using visuals to hold a user's hands through the checkout process. Buttons are visible and consistent. The Add to Basket *button is stylized the same way throughout, and thumbnail images of the selected products appear in the shopping cart.*

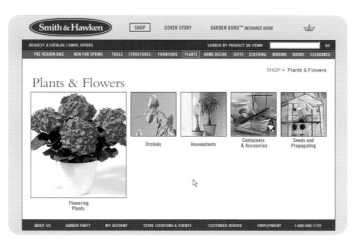

First level. *The product presentation is very structured online. The Web team can't lay out the product selection with cross merchandising as the catalog does, so for each category, one hero product is featured in a large image at left.*

Third level. *On the product level page, the third level down, there's just one item per page. And look at all the white space!*

Second level. *This is the next level as you drill down. To maintain consistency and control—and to prevent visitors from feeling like they're being bombarded with random images—the first image remains constant.*

<THE COMPANY>

Since early 2000, Castor & Pollux Pet Works has made and distributed premium pet products. Although its primary distribution channel is retail grocery stores, the company wanted to use the Web to extend the reach of its brand. Also, establishing a new brand in retail stores took longer than the company had anticipated, so building trust online became even more important.

<THE SITE>

The Castor & Pollux Pet Works Web site had to convey the unique qualities of the brand—exclusive and high-end—while remaining focused on the user. The site offers only thirty specialized products, but instead of feeling small, the site feels manageable. Visitors are not overwhelmed with choices, and find it easy to select the products they need. The result is a successful translation of an offline brand to a user-friendly digital brand.

Company type: Maker of premium pet products for consumers

Web Site address:
www.castorpolluxpet.com

Designers: Tweak Interactive (Portland, OR)

<THE USERS, THEIR GOALS AND THEIR TASKS>

The target market for the Castor & Pollux Web site is female pet-lovers who have money to spend on their animals. "They have some experience shopping online but aren't super-experienced," says Lara Cuddy, lead designer on the project. "So they need to be able to trust the site. That's why the homepage has an old-fashioned look intended to be friendly and approachable."

User research supported assumptions made about this target market: they're in a high income bracket, have fast machines and quick modems (though not necessarily high-speed connections).

The site is graphic-intensive, with icons and illustrations, graphic headers and photographs. Although designers were not too concerned about users' connection speed, the site was designed to load as quickly as possible. The graphics have as few colors as possible and were carefully optimized for quick download.

One level down are the shelf pages for each product category, such as Red Rover dog toys. The graphic quality of the icons and illustrations lends itself to rendering in only a few colors so the images can be formatted in relatively small GIF files.

The photographs of the products are JPEGS that were designed and shot specifically for the Web so the files would be smaller than those of regular photos. For instance, the cat toys on the Curious Cat shelf page were shot in limbo space with a white background so they appear to be floating. Photographer Michael Dahlstrom, who specializes in photography for the Web, explains that extraneous objects, even backgrounds, increase the file size of the JPEG. So these photos are strictly product, which also helps bolster the personality of the brand.

This page is also heavy on graphics, but all the branding elements—typography, graphic headers, badges and buttons—are in limited colors chosen from the Web-safe palette, with no special rendering or illustration.

The team quickly learned that names of sections and subsections are very important, and that if the buttons didn't take users where they expected to go, frustration would likely follow. On the original log-in page, the red headers offering two options—create an account or log in—was confusing. It wasn't clear to users that if you already had an account, then your task was to log in to that existing account. As a result, when a shopper who already had created an account came back to the site to buy more, he or she often created a new account instead of logging in to their existing account. The solution was to include additional prompts ("Already a customer?" or "New Customer?") just above the red headers. These additional cues ask shoppers to further define themselves, which in turn helps them to complete the log-in process.

GIFS AND JPEGS

GIFs are perfect for smaller graphics that should look crisp and clean, but don't need more than 256 colors. Simple company logos, small buttons, and navigation bars are good examples of graphics that should be saved in GIF format. Unlike JPEGs, GIFs are a "loss-less" compression format, so the details of your graphic won't get blurry. If you're scanning something like a finely detailed map, the GIF format is best to display it. Keep in mind that using GIFs for large pictures leads to huge file sizes and long download times. And although you can't compress GIFS, you can reduce their bit depth, which means limiting the number of colors.

JPEGs, on the other hand, display thousands of colors and can often be compressed into much smaller files than GIFs. They're great for photo-style graphics. Remember that when you compress a JPEG you'll dirty up some of the photograph's finer details.

(For more on GIFs and JPEGs, go to Webmonkey.com, an excellent resource site for Web design.)

For a product-oriented site, there is a lot of text here as you drill down to the actual pet products. Because the pages are dynamically generated from a database on the fly each time a user calls that page up, copy restrictions substantially impacted the design. Cuddy and her colleagues created a template that standardized the subheader, the banner, the length of the description and more, keeping the copy brief and relevant typographic information above the fold, at a fixed width for 800 x 600 screen resolution.

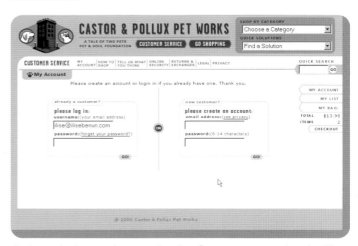

On the new log-in page, the two sections (one for new customers and one for old customers) are clearly delineated. To clarify further, additional questions were added.

WHAT DOES A DESIGNER NEED TO KNOW ABOUT PHOTOGRAPHY FOR THE WEB?

According to Mike Dahlstrom, a photographer who specializes in Web photography, designers need to know that images on the Web have three components: color space, contrast range and file size.

Of paramount concern is the quality of the target audience's viewing environment. Designers or photographers may look at their monitors—which have been calibrated to ensure consistent color—in controlled rooms with dim lighting (and soft music playing in the background). However, in someone's home, the computer might sit on a desk in a sunlit room and may be used at any time of day or night. These conditions affect how an image will appear by making it more or less distinguishable.

Color space is the dynamic range of colors available to a viewer. When the Web first took shape, most monitors were constrained to a palette of 256 colors (today known as Web-safe colors). The entire visible spectrum had to be squeezed into these 256 colors, with excess colors irretrievably eliminated. Although today millions of colors are available on most computer monitors, the mass market still requires the color bar to be set for the Web safe palette, giving the designer confidence that almost everything used in an image or design will be seen as intended.

Contrast range is defined as darkness (black) to lightness (white) on a scale of 0 to 255 (black to white). 0 is the deepest tone a computer will present, having no detail; 255 is the brightest tone a monitor will present, also having no detail (like the white of a page). So the image must be presented within those constraints, with some "wiggle room." This can be accomplished during the photo shoot by exposing for the highlight area, then filling light into the shadow areas to bring the values up. It can also be accomplished in Photoshop as a secondary source of control by adjusting the contrast range in either levels or curves.

The size of an image should be controlled in the capture by photographing (or scanning) to a size approximate to the desired finished result. Downsizing a file in Photoshop is generally acceptable as it does not necessarily affect the quality of the image. Upsizing, on the other hand, is generally unacceptable much above about twenty percent, since you are asking software to create image information where there is none available. The second component of downsizing a file is compression. A typical Web ready photo is saved as a JPEG file format. JPEGs introduce file compression at the expense of quality (the more the compression, the lower the quality). They do this through mathematical calculations that remove redundant information, thereby making the physical (transmittable) file much smaller. Most Web preparatory programs as well as image programs (like Photoshop) can save JPEGs with a user-defined level of compression. Once information is lost through compression, however, it cannot be retrieved.

The objective here is to compress the image to the smallest file size that can deliver the degree of quality you desire. There is no formula for this. If your target audience is viewing a site over a dial-up connection, you probably want the smallest file size possible, and you may have to sacrifice some image quality to achieve that. If your audience is high-end, with high-speed connections, you can opt for more quality and slightly slower download speed.

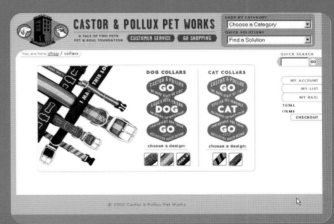

This is a good example of contrast and file size management. The highlights on the clips maintain tone and separation from the background white, while the black collar in the foreground is not "black" but a dark gray to maintain some detail in the webbing. The black in the original capture was about 30 and the buckle highlight 250. The image size at the final dimension was approximately 3.5" x 3.7" (8.9 x 9.4 cm) at 72ppi and the file size was 200k. Saving it as a JPEG compressed to level 4 yielded a file of 20K. The entire page probably does not exceed 50K in size, but the images maintain enough color and detail to be acceptable.

ASHFORD

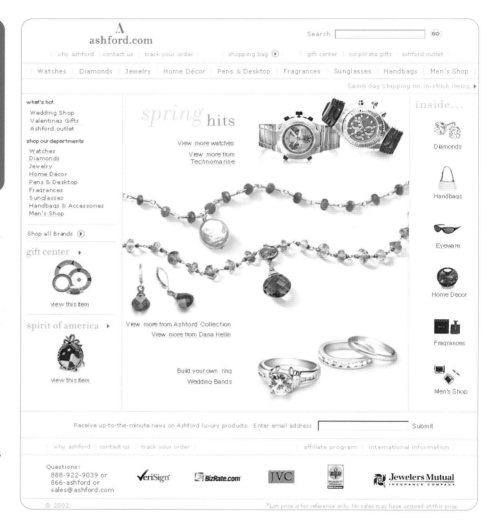

Ongoing design makeover, shift to product-oriented focus

Company type: Internet retailer of watches, jewelry and other accessories

Web site address: www.ashford.com

Designer: Jeff Walker, In-house Creative Director

<THE COMPANY>

Ashford Inc., one of the first luxury e-tailers, started as an Internet company in 1998. Although the company has since built a small retail store in Houston, over ninety-eight percent of their business comes from e-commerce. The bricks-and-mortar store used by local customers is much like a regular jewelry store, except that it has computer terminals available for browsing the full selection of products on the Web site.

<THE SITE>

When it launched in 1998, Ashford.com featured only high-end watches. Jewelry, diamonds, writing instruments and handbags were added in 1999.

Ashford.com has been redesigned three times since 1998 and each time, according to Jeff Walker, Creative Director for the site, there has been a clash of sorts between the marketing, technology and creative departments. The conflict begs the question: "Is a homepage meant to be for advertisement, navigation, and branding, or is it a store-front or display case?"

This is a very common dilemma. The marketing department feels that every new promotion needs to shout louder than the last (which may still be on the page), so the featured product is overwhelmed by headlines, buttons and logos. The technology department needs to establish a stable, templated platform to manage the large amount of data (images, text, prices, descriptions) required for a large and constantly expanding e-commerce site, so the aesthetics and branding so carefully cultivated by the creative department get undermined.

"It wasn't until the third redesign that we got the balance right," says Walker. "This makes sense in retrospect. When the site was in the hands of marketing and then technology, merchandising and retail decisions were being made by engineers and media buyers. That's like giving responsibility for marketing a luxury department store's products to the foreman of a construction crew."

<THE USERS, THEIR GOALS AND THEIR TASKS>

The users (or customers) of Ashford.com are middle- to upper-income, mature people who can afford nice things and don't care about shopping in high-end department stores. Jeff Walker says, "They can shop in both Wal-mart and Neiman Marcus." Some of them are Internet-savvy, and some are not. And while some log on from a dial-up connection at home, Ashford.com's data shows that eighty percent of their orders occur between ten a.m. and four p.m., indicating that people are in the office on a broadband connection when they purchase the product.

When Walker joined Ashford.com in 1999, the site was pretty traditional: previous homepages featured lifestyle images with very little product; visible product pages featured tiny thumbnail images with lots of editorial and sales text.

Ashford.com has come a long way since then, as Walker has made it his priority to shift the focus gradually away from the text-heavy editorial format of the early iterations. The most recent iteration features a bright, crisp design that is completely product-focused and that stands apart from the cluttered, busy, hard-sell format favored by many e-commerce sites.

The first step toward a product focus was the first homepage Walker developed for the company in 1999.

"Our users are spending a lot of money on a product that's all about style and design. It's a shiny bauble," says Walker. "That's why our site has the biggest detail pages and the biggest thumbnails."

<GOALS OF THE REDESIGN>

Because of the site's product focus, the over-arching design challenge is to convey a sense of luxury while maximizing limited screen space. To do that, Ashford.com depends on high-quality images, which—yes, it's true—make the pages download slowly. Download speed is important, but since this site is all about product, the company decided to sacrifice those users with dial-up connections (for them it will be slow, but worth it) in favor of a higher-quality display.

Still, for all the talk about throwing download speed to the wind, Walker and his team do try, whenever possible, to limit the amount of bandwidth required. "Everything you put around the product detracts from its design. That's why there is no lifestyle imagery, no women on horses on the beach."

It is a tradeoff, and certainly may alienate customers with dial-up connections; but users need to see details which wouldn't come through if the images were smaller. And while the images are large, their color palettes are controlled. All the products are presented on a white background and are all in the same color range: platinum, gold and so on. Extraneous color is eliminated, which limits bandwidth use and speeds download.

Operating on the idea that a pretty picture—especially a big one—is all you need, sales copy is kept to a minimum. Simple headlines (often one word) are used to describe the products. This strategy makes sense also because statistics show that task-driven users skim rather than read most text on the Web.

But that doesn't mean the site is all GIFs. Indeed, as much as images are used to present product, the eventual goal for the site is to use text as the exclusive navigation strategy. In the interim, both images and HTML text

One goal of the latest design was to remove every bit of color, especially on the pages with jewelry and diamonds. "Those stones are very, very difficult to capture on the Web. If you put any other color on that page, it makes that stone look insignificant, especially if you are using platinum for the metals. If the metals are gold, you can use color more in the secondary areas," explains Walker.

are used for navigation, although visitors to Ashford.com usually click on the image first. That's why Walker recommends that images always link to the most strategic place, such as a product grouping or a single product page, and that text links under the image describe where visitors are going or what they are looking at.

Walker believes that, aesthetically, it's more honest to use HTML. "GIFs on a Web site are primarily a legacy from the print world. On an e-commerce site, text is almost always a link; that's the proper way to communicate information. Images are used to show the product, which you can't do with text." As the site evolves, all image

map navigation is being stripped so that, eventually, all navigation will be text links. Not only will this speed downloading, but it will ease maintenance on the back end of a site with constant changes for new merchandise and featured specials.

EVOLUTION OF A DEPARTMENT PAGE

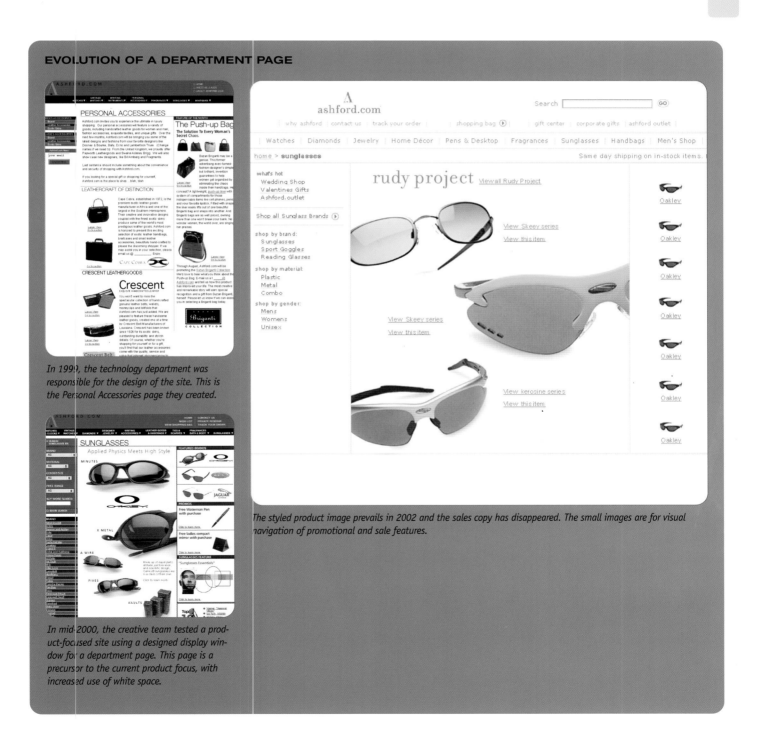

In 1999, the technology department was responsible for the design of the site. This is the Personal Accessories page they created.

In mid-2000, the creative team tested a product-focused site using a designed display window for a department page. This page is a precursor to the current product focus, with increased use of white space.

The styled product image prevails in 2002 and the sales copy has disappeared. The small images are for visual navigation of promotional and sale features.

<THE ORGANIZATION>

Consumers Union, publisher of *Consumer Reports* magazine and ConsumerReports.org, is an independent, nonprofit testing and information organization. Since 1936, the company's mission has been to test products, inform the public and protect consumers. It is a comprehensive source for unbiased advice about products and services, personal finance, health and nutrition, and other consumer concerns.

<THE SITE>

ConsumerReports.org is the largest paid-content, general consumer site in the United States, with over 800,000 paid subscribers as of March 2002. The site holds four years' worth of data, and although no one actually knows the total number of pages, it is in the five-figure range.

The overall goals for the site are:

- to be the most trusted and easy-to-use online resource helping consumers research all manner of products and services.

- to extend the reach of the *Consumer Reports* franchise to a wider and younger audience.

- to leverage the power of the Web, with its interactivity and customization, to better serve customers.

<THE USERS, THEIR GOALS AND THEIR TASKS>

Consumer Reports magazine has four million paid subscribers, and many of these print subscribers have become subscribers to the Web site as well. According to user research, however, the two groups are clearly distinct, differing in their online habits and familiarity with the Web. For example, the median age of magazine subscribers is fifty-five, while the median age for Web site users is younger, closer to forty-four.

Consumers Union has done extensive user research and discovered many significant and useful facts about their Web site users. Here's the hard data as of 2001:

- Connection speed: the majority of users have a 56K modem.
- Screen resolution: 90% use 800 x 600 or more.
- Browser: 65% use Internet Explorer, 11% use Netscape
- Platforms: 95% are PC users, 5% use Macintoshes

Subscribers to the site are well educated, with a median income of $87,000 per year, and they tend to have the latest and the best of everything. As for their online habits, they use the Web as their primary means of research. When they need to find something, they go online first—but they don't necessarily go to ConsumerReports.org first, or even exclusively. These are smart shoppers and they use multiple Web resources; but ConsumerReports.org is the most dominant among them.

Because the site is owned by a nonprofit organization whose mission is to disseminate information to inform and protect consumers, anyone who visits ConsumerReports.org can access free information on topics ranging from how to buy a car to what to expect from a new gas range. They also offer product safety recalls—one of the most popular features both online and offline, especially when it comes to children's products.

The majority of visitors to the site, however, buys a monthly or annual subscription for the sole purpose of researching specific products prior to purchase. They look around, check other sites, such as those of manufacturers and retailers, then they log on to ConsumerReports.org to evaluate product selection and to make their final decisions. While some use the online information and ratings to justify a purchase they've already made, the product information found on Consumer Reports.org is more often the clincher for most major purchases.

<GOALS OF THE REDESIGN>

Research showed that visitors to ConsumerReports.org, unlike readers of the magazine, don't browse the Web site—a discovery that surprised the Web team. Like many online researchers, these users are task-driven. They know what product they're looking for and they want to find it quickly. Research indicated that on the previous iteration of the site, users had trouble finding the four most popular product categories, which were buried in an alphabetical list.

Another problem was that people could not easily discern what information was offered for free and what was accessible only by subscription. As a result, one the primary goals of the redesign was to clarify which content was free and which carried a charge.

It was hard to find common information that most consumers wanted on the old site.

The site also needed to reflect and support the solid reputation for values, objectivity, and trustworthiness that *Consumer Reports* has built over the years. Although there's no other site that covers as many product categories, there are sites that offer similar information, including those of manufacturers, retailers, and e-commerce merchants. Unlike these other sites, however, ConsumerReports.org does not sell anything other than its evaluations, recommendations, buying guides and similar publications. It was essential for the Web site to emphasize that distinction.

Building on the *Consumer Reports* brand doesn't mean simply transferring the *Consumer Reports* logo onto the Web site—which was the initial effort on the old site. The addition of ever-increasing, up-to-date information, videos, interactive charts and information graphics help make the newly designed ConsumerReports.org more useful to subscribers than the older version of the site.

Because information is the focus, graphics are kept to a minimum. Nothing blinks on the homepage. Individual graphics are kept

to 30K or less. Rules, bullets, icons, tints and other visuals are used sparingly. The intention is to keep the pages uncluttered, white, and as clear as possible.

The page is divided into three columns. The left panel contains the Ratings Reports and other material available only to paid subscribers. The middle panel offers highlights and other free content. The right column is self-promotional, used for house ads promoting online and offline information products sold by Consumers Union. A light

yellow tint differentiates these materials from the other content.

Animation and multimedia are used only to enhance the research, not gratuitously. For example, the Auto section offers (in QuickTime) a tour of an automobile test track showing tests in progress with full-motion video and sound. "We're not here to dazzle them, but to offer the best and most trusted information we can," says George Arthur, Design Director for *Consumer Reports*.

The same ratings icons used in the magazine—the red logo circles—were brought into the Web site to reinforce the branding.

Designing the ConsumerReports.org logo on one line supports the overall Consumer Reports brand, yet gives the Web site its own distinctive character. Graying the "org" created a double-duty brand-plus-URL.

Subscribers can access the Ratings in a variety of easy and intuitive ways. More options present more opportunities for people to quickly find what they're looking for; the designer's challenge is to provide options without cluttering up the page. On this site, visually-oriented users can click on a picture of the product; readers can click on the word, and anyone can use the panel of colorful tabs. Scrolling over the tabs offers subnavigation for each header, which then links to one of the subcategories.

In the redesign of the site, the layout and navigation of the ConsumerReports.org homepage takes into consideration the fact that a full 85% of site traffic is researching one of the four main areas—appliances, electronics, autos and computers. Each of those categories has its own tab, allowing the products to be found almost instantaneously. "We've taken the most obvious destinations and products that we know people are looking for and we stick those up front to make it easy for people to find the latest info," says Arthur.

STAPLES, INC.

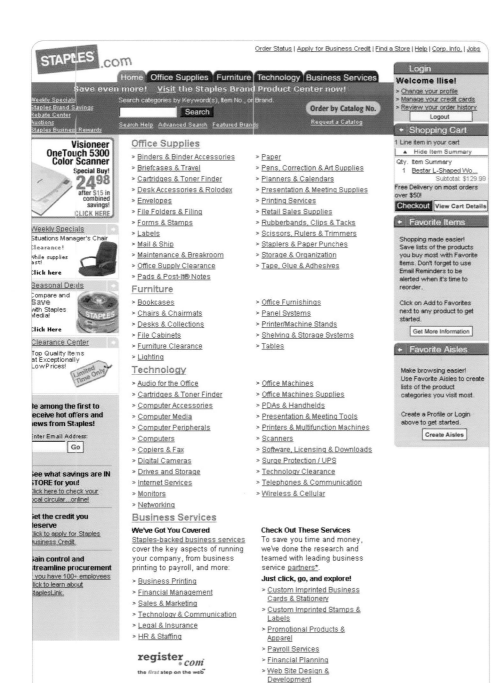

Registration makeover

Company type: Office supply retailer

Web Site address: www.staples.com

Designer: In-house, Colin Hynes,
Director of Site Usability

<THE COMPANY>

Staples, Inc. is an $11 billion retailer of office supplies, furniture, business services and technology to consumers from home-based businesses to Fortune 500 companies in the United States and abroad. Staples invented the office superstore concept and operates more than thirteen hundred office superstores, in addition to selling through mail-order catalogs and e-commerce.

<THE SITE>

Staples.com, the online extension of Staples, Inc., is an e-commerce site focused on serving small businesses. Launched in 1997, the original Staples.com targeted the office-supply market. The site is constantly being remodeled; different areas have undergone makeovers at different times.

<THE USERS, THEIR GOALS AND
 THEIR TASKS>

The site has more than one million registered customers, most of whom are businesses with fewer than a hundred employees. The target audience of Staples.com is companies with eight to fifty employees. Although these businesses may be similar in size, the people buying supplies within those companies do not necessarily have much in common; in fact, they often have very little in common. In small firms, the person buying supplies could be the CEO, while in larger firms it could be an administrative assistant.

Staples.com attracts two distinct buyer types. One type of buyer is very organized and proactive, keeping an eye on the level of supplies available and restocking well before they run out. The other, meanwhile, is just the opposite: a reactive type who orders only when supplies are near or at depletion.

<GOALS OF THE REDESIGN>

The focus of a recent makeover was to redesign the registration process to decrease the drop-off rate—that is, the number of people who abandon the process before completing a purchase.

To probe into this issue further, Staples.com asked three hundred registered customers via an online survey which questions they thought were appropriate for an online registration form, as well as which of the existing queries annoyed them. "Registration is not an area where you want people to leave, so we took the results of this survey very seriously," says Colin Hynes, Director of Site Usability for Staples.com.

The usability team followed up that survey with an expert review of the registration process and another usability test to confirm other areas that caused user dissatisfaction.

Incorporating the user feedback, Staples.com simplified its profile-creation pages and reduced the amount of information requested. The result is a cleaner, easier-to-use page.

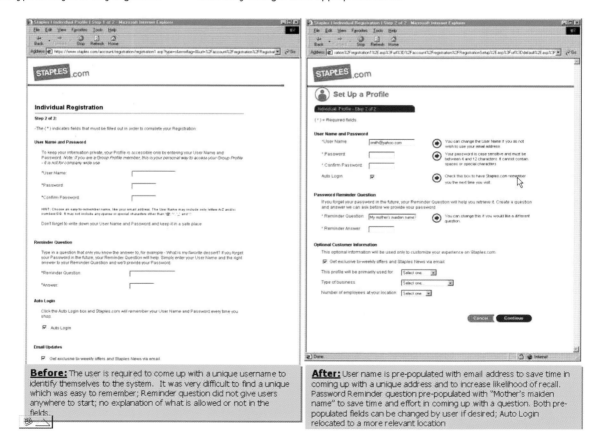

Before: The user is required to come up with a unique username to identify themselves to the system. It was very difficult to find a unique which was easy to remember; Reminder question did not give users anywhere to start; no explanation of what is allowed or not in the fields.

After: User name is pre-populated with email address to save time in coming up with a unique address and to increase likelihood of recall. Password Reminder question pre-populated with "Mother's maiden name" to save time and effort in coming up with a question. Both pre-populated fields can be changed by user if desired; Auto Login relocated to a more relevant location

CHECKLIST FROM DESIGN ELEMENTS FOR AN E-COMMERCE WEB SITE

- ■ **Price.** *Does the design support the customer's price-conscious shopping habits by revealing all costs up front; facilitating price comparisons; and emphasizing attractive price options such as sales, discounts, and specials without distortions?*

- ■ **Variety.** *Does the design reflect an accurate representation of products on the site by exhibiting the breadth and depth of product variety readily, assisting customers in accessing the entire range of products, and directing shoppers between intuitive and cross-referenced categories?*

- ■ **Product information.** *Does the design provide information about products in a way that best facilitates a customer's decision-making by making all information easy to access, considering reading and learning habits of customers, and enabling comparisons in the form of lists or tables?*

- ■ **Effort.** *Does the design minimize the customer's effort by providing clear navigational links on every page, allowing shoppers to access products in a variety of ways, and ensuring customers are always well oriented within the site by providing breadcrumb trails or other navigational aids?*

- ■ **Playfulness.** *Does the design create an experience that moves beyond merely providing information and a transactional channel by offering unique forms of entertainment and generating novelty through exciting features that demonstrate innovation?*

- ■ **Tangibility.** *Does the design creatively compensate for the lack of sensory input in ways supported by current technology?*

- ■ **Empathy.** *Does the design show consideration for individual shopping styles by personalizing without intrusion, thus offering customers multiple ways to shop and leaving them in control of the shopping experience?*

By Wendy Winn and Kati Beck. Reprinted with permission from TECHNICAL COMMUNICATION, the Journal of the Society for Technical Communication Arlington, VA.

USER PROFILE: CONNECTION SEEKER

>>>>>>

WHAT GOALS DO CONNECTION SEEKERS HAVE?

- ▪ To meet people of varied backgrounds and cultures
- ▪ To exchange ideas on topics of mutual interest
- ▪ To establish meaningful, interactive relationships

Maggie Batista

Demographic: Female, 29, single

Occupation: Director of User Experience at Terra Lycos

Personality traits: Quirky, charming, spicy

Online habits and behaviors: "Because of the nature of my job, I'm online eight to ten hours per day via a T1 connection. At home, I have a cable modem, so I'm online one to three hours per weekend."

Web history: "I've been a regular Internet user since my first year of college, in 1991. I started using the Web in 1993, so it's been almost a decade now! I got online initially to connect with other people. When I discovered I could get paid for doing what was fun for me, I stuck with it."

Favorite Web sites: Nerve, Amazon, Yankees.com, and several friends' blogs and journals.

Usability pet peeves: Script written into a site so that it doesn't allow me to use the back button, pop-up ads, broken links

How do you search? "Why waste time? I type in the keyword and press enter—it's that easy. A search engine is always a great place to start when looking for something."

What are your typical online goals? "I use the Web to find information and connect with someone. I use e-mail to communicate with far-away friends—in fact, the written e-mail has even improved some of my relationships! The Web has made meeting people a lot easier and a lot more regular—and has even made me feel more confident meeting people in regular social situations."

CONNECTION SEEKERS

Much has been written about the Web's potential to promote obsessive isolation, and it's certainly true that some people may use it to stay disconnected from the real world. But people looking for connection—connection seekers—will find on the Web a smorgasbord of opportunities to meet and connect with people around the world, to share experiences, and to develop bonds by exchanging ideas on topics they care about.

In his book, *Small Pieces Loosely Joined* (2002), David Weinberger writes that the Web is a new place for us to be humans together in new ways. "In the real world, our connections have usually been to the people who happen to live around us: our family, our neighbors, the people who go to our school or where we worship. But on the Web, we are not separated by space. We are joined...by e-mail, chat, instant messaging and by hyperlinks."

It is quite amazing that no matter who or what or how you are, you can find people with whom to exchange ideas and from whom you can learn—people you would normally walk by on the street without a second glance.

Connection seekers are people who go to designforcommunity.com to read and respond to ongoing discussion topics; they are potential volunteers searching VolunteerMatch.org for a place to lend a hand; they are Red Sox fans looking to connect with others via the weblog, Bambinoscurse.com. They might be parents of children with learning problems looking for support at Schwablearning.com, or they may be lonely people making an effort to meet others for fun and frolic on Nerve.com's personals site.

When it comes to communicating with others on the Web, connection seekers aren't in surf mode. They are curious and interested in seeing who and what is out there. They have a goal in mind, but they are open, searching, and willing to take their time.

DESIGN FOR COMMUNITY

Derek Powazek's book Design for Community *(New Riders, 2001) approaches online community from a design perspective, discussing the impact of site interface and architecture on community interactions:*

In my experience with the visual design of community spaces, I've seen some common threads. And though it's hard to quantify exactly how much the visual design of a community space contributes to the quality of the contributions, it's impossible to deny that one directly influences the other. Here are a few areas to consider in the design of community spaces.

Shapes and patterns

When creating a community space, it's important to create a space that is warm, welcoming, and inclusive. When translated into pixels, these things often mean soft warm colors, curved elements, and photos of friendly faces. Are these things cliché by now? Probably, but only because they really work.

Think about real world objects—things that feel good in your hand. The curve of a stone that's been polished by the ocean, the feel of an old baseball that's worn soft from use, the feel of a warm blanket on a sunny couch.

You can't replicate the sensual feel of these things on the Web, but you can create visual reminders of them. These things have elements in common: smoothness, curves, and warmth.

That's why so many community areas use curved elements with warm colors. They're designed to make you feel more comfortable. The idea is for them to feel organic (which they are, since they grow with people) instead of cold and technological (which they are, being Web sites on computers).

Photos and illustrations

Another common element is photos or illustrations of people. This is designed to humanize a site and remind you of the real people on the other end of the usernames. This can be a great way to make a site feel personal, but be careful with it, because it can just as easily backfire. Once you've seen one fake clipart smile, you've seen a million. And if your users sense that they're being manipulated, they'll resent you for it. So if you're going to use humanistic imagery, my advice is to use real photos of real people connected to your site. An amateur photo that's real will do more to accomplish humanizing your site than a legion of fake smiles from Photodisc.

Attention to detail

One of the most common issues in community sites is making clear who is speaking at any given time. People understand who's talking to them when they read a newspaper. A newspaper writer, who is a trusted voice that works for the newspaper, is saying something you can believe.

But when you add community features, you introduce a third voice, and one that's not always trustworthy. If your site has both official editorial and community contributions, it's imperative that you differentiate the two visually.

It gets more complicated, too. If you have official moderators or hosts, they speak with more authority than the rest of the posters. They, too, need to be visually distinguished.

Design can answer each of these issues in delightfully nonverbal ways. Simply changing a font color slightly to increase or decrease contrast can communicate a lot of information.

Excerpt from Design for Community by Derek Powazek (New Riders, 2001.) www.designforcommunity.com

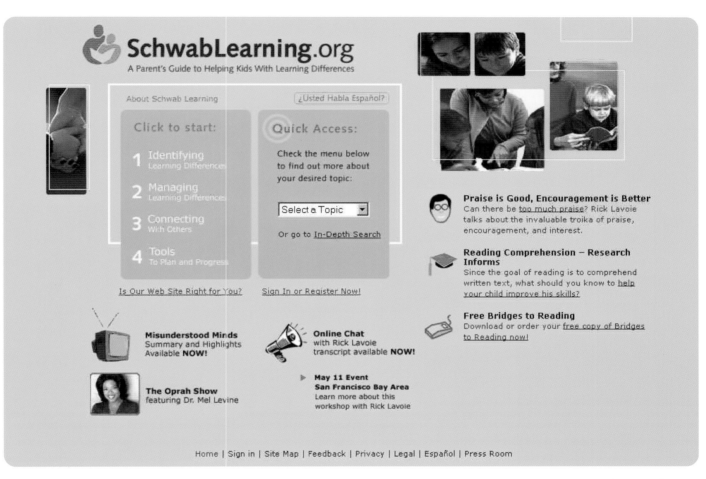

<THE COMPANY>

The Schwab Foundation for Learning, established in 1987 by financier Charles R. Schwab and his wife, Helen O'Neill Schwab, is a nonprofit organization dedicated to helping kids with learning differences be successful in learning and life.

<THE SITE>

Schwablearning.org is both a community and informational site offering a wealth of helpful articles and resources on topics such as dyslexia and attention deficit disorder, as well as online forums where parents can connect with others and share their own experiences. The site's objective is to teach parents that they are the best advocates for their child, and to use information and resources to move them toward that "management" position.

The project to overhaul the brand and redesign the site was assigned to San Francisco-based interactive firm Small Pond Studios. The team looked at what caregivers for children with learning differences would need from the foundation, and how the Web site could facilitate that relationship.

Site makeover

Company type: Support organization for parents of children with learning differences

Web site address:
http://schwablearning.org

Designers: Small Pond Studios (San Francisco, CA)

<THE USERS, THEIR GOALS AND THEIR TASKS>

The users of Schwablearning.org are parents, primarily mothers, who come to the site knowing little or nothing about learning differences. Some may have done a little online shopping, but these moms are not very experienced with the Web and most dial up either with kids in the room or in the wee hours of the night.

One goal of the revised site was to create a comfortable environment for caregivers. While most visitors are mothers, the Web team wanted the site to be welcoming to both men and women, as well to diverse races and cultures; so the images on the site are photographs of real people in all varieties, not models.

The new site is much more user-oriented. It is organized around the process a parent goes through when faced with the issues of learning disabilities. This is reflected on the homepage and in the left navigation bar that follows users wherever they go in the site. Parents can easily navigate through the three steps in the process: *Identifying a Learning Difference, Managing a Learning Difference,* and *Connecting with Others.*

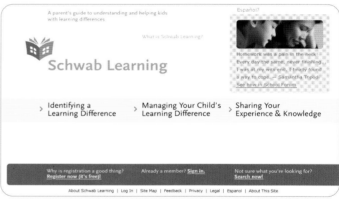

The original site was a huge clutter of information and very difficult to navigate. It had grown organically over four years, with a vertical structure that didn't support cross navigation. As is common on sites that don't anticipate growth, little consideration had been given to what users needed, wanted, or could use easily.

During development, designers considered various styles for the site, from informative and "bookish" to clean, white, and organic. The look they chose softens the severity of the subject with warm, welcoming design elements.

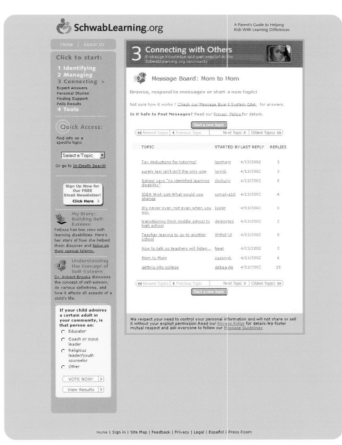

Recent discussions in the community forum are listed on the main page of the message board section and topics are organized chronologically, with the most recent one at the top. Users needn't register or provide any personal information if all they want to do is read the postings, although they do need to log in if they want to contribute to the discussion. A user has only to click on the text link of a topic to read the entire thread of the discussion, or a series of questions, answers and comments.

Because most visitors come to read the information, and the site has a lot of text, graphics are kept to a minimum, but color is used for visual interest. The warm yellow background is bright, lively, and deliberately cheerful, though not too feminine or masculine. Yellow is also considered a color of intelligence. Rounded orange text blocks are simple attention-grabbing pieces that make navigation clear, offering enough contrast for the text to be readable.

Links are almost all text links, making it easy and fast to download. Pop-up windows are used here and there to offer additional content or functions that otherwise would lead to dead ends.

Most mothers depend on word of mouth, and sometimes they are more comfortable with other mothers than with experts. So besides the resources and content created by Schwab Foundation for Learning, the site's main feature is its community forums, where parents can share their experiences and learn from those of others. The message boards, called *Mom to Mom* (although dads and other caregivers are welcome as well) provide a forum for parents to exchange information and find support.

The exchanges on the message boards are informal and conversational. Many come to the site anxious or distraught, perhaps having just learned about their child's condition. They may post a question hoping for a quick answer, or seeking feedback to allay fears. Once registered, anyone can start a discussion by posting a question or comment, which is then displayed on a yellow background. Replies—five at a time—are displayed below. Although many replies may be quite long, visitors are already engaged and willing to scroll.

Any registered visitor may respond to a posting simply by scrolling to the end of the last comment (or the bottom of the page) and clicking on *Add your reply*. When there are more than five replies, the site helps visitors keep track of a discussion topic by repeating the original posting at the top of each additional response page.

To aid unsophisticated visitors, the layout is consistent from page to page, no matter how deep a user delves into the site. The orange navigation bar is always on the left; the content block—on a white background for legibility—is always on the right.

Following the guidelines set out in *Design for Community*, Schwablearning.org keeps the content and community together. While browsing the message boards, users can always find links to other areas of the site.

VOLUNTEERMATCH

<THE ORGANIZATION>

VolunteerMatch is a nonprofit online service launched in 1998 that helps match interested volunteers with community service organizations throughout the United States.

<THE SITE>

The Webby Award-winning VolunteerMatch site is, in essence, a clearinghouse for volunteering opportunities nationwide. The Web site provides free listings to more than nineteen thousand nonprofit organizations that need help. Visitors can simply type in their ZIP codes to scan a menu of nearby volunteer opportunities, or search for a specific agency or event. During its first four years, the site made nearly three-quarters of a million matches.

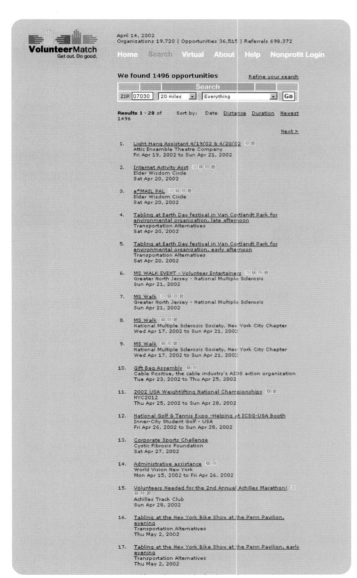

As visitors drill in to the site to find more information, there is a consistent visual layout from page to page, so that the information truly becomes the main focus for the user and once someone has used the system, it becomes intuitive. Tiny icons are used to indicate whether opportunities are kid, teen, senior, or family/group friendly. Although the icons are small, alt-text is used to support and substantiate them, reminding users of what each icon represents so they don't have to remember or if they can't see it.

<THE USERS, THEIR GOALS AND THEIR TASKS>

The main task here is to connect volunteers with organizations that need them. The site is designed to serve two audiences, both equally important to the process: people interested in volunteering, and community service organizations that want to recruit them.

In August, 2001, the research firm Harder + Company concluded a formal survey of VolunteerMatch designed to help them better understand exactly who their users are, and how to improve the service for them. Here's what they found:

The individuals who use VolunteerMatch are disproportionately female (81%, up from 77% in 1999). 65% are between the ages of eighteen and thirty-nine, with the smallest group of users (1% of respondents) identifying themselves as senior citizens. 66% have a college degree or higher and 55% placed themselves in the range of $35,000 or above for household income—the same range as the national average income, indicating that the Internet is becoming more accessible to the average family. One conclusion drawn from this data is that most of VolunteerMatch's users are likely to be very familiar with computers and the Internet.

More than half (63%) of the community organizations that use VolunteerMatch are small nonprofits with budgets under $1 million and ten or fewer full-time paid staff members. Most (96%) rely heavily upon volunteers to achieve their missions, which means they are precisely the ones most likely to be in need of volunteers and most unlikely to have the necessary resources to utilize the Internet for recruiting volunteers. Some that do have the necessary resources prefer to take advantage of VolunteerMatch's name recognition.

"The bottom line with VolunteerMatch is that we want people to visit us not for the point of visiting us, but to satisfy either their desire to volunteer or their need to recruit volunteers," says Jason Willett, Director of Communications. "If they get into our site, find what they are looking for, and then get off our site to actually (and hopefully) make a positive difference in our communities, we feel like we have succeeded."

<GOALS OF THE REDESIGN>

For both volunteers and organizations, the single most important feature of the service is that it is easy to use. In 2001, Volunteer-Match redesigned the site to offer more user-friendly features that were all user driven. These included photos of volunteers and volunteer administrators, icons to indicate the types of opportunities available, and improved sorting options (by date, distance, most recently posted, etc.) All of the features are designed to bring volunteers and service organizations together by making it easier than ever for the two groups to find each other.

According to Willett, "the intention of the site is to take advantage of and convert volunteer inspiration into volunteer action as quickly as possible." To that end, the company is constantly streamlining navigation to minimize the number of clicks between a user and the requested information.

Volunteermatch.org does not want users to be distracted by the design of the site, so the layout is very simple: it employs very few graphics and a single text style. The new VolunteerMatch homepage provides a lot more information, but it doesn't look cluttered. It's easy to find the information, whether it be popular cities, recent opportunities or major charitable organizations.

According to Luke Knowland, Director of Web Production and Development for Volun-teerMatch, "It's a matter of figuring out which is the important data to the user, and breaking it down into manageable amounts. I see it as a dashboard. I took a look at what data we had and wanted to present to the user, and figured out how to present it in an informative yet not overwhelming fashion."

One goal for the new site was to make it easy on the eyes, which was accomplished by using a muted color palette on a gray background, rather than the primary colors on the

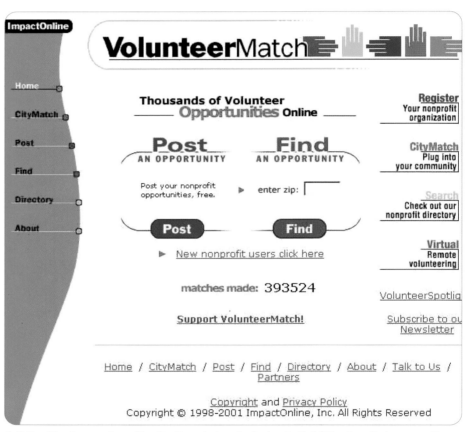

Both the old and new versions of the site allow volunteers to simply enter their ZIP code on the homepage, then click Go to access information about opportunities in their communities. On the old site, however, there was navigation on literally every side of the screen—top and bottom, right and left. Much of it was redundant and therefore confusing.

white background of the old site. "In developing a color palette, it became evident that by keeping a white background, the overall calming effect of the muted colors was lost—the stark black text on white background became jumpy—and the overall visual design began to suffer," explains Knowland. "The light gray provides relief from the traditional bone-white background of older sites, while maintaining the requisite contrast between text and background."

The framing color bars are intended to provide some visual flavor to what is essentially a database of text. The color coding system is a muted version of the hand colors in the VolunteerMatch logo, and makes slight reference to the original design of the site, where vibrant colors previously had been associated with each section. Beyond that, it serves as a visual key to the user, providing consistency between sections.

On the new site, the navigation bars were made less redundant and more intuitive. Instead of three links to *Find* there is now only one, prominently displayed in the middle-left of the screen.

Powered by a database, the site is basically all text, which allows quick downloading. The few photographs of volunteers and volunteer coordinators have a definite purpose: to put a human face on volunteering. Moving a mouse over the color bar across the middle of the homepage changes the photo and the testimonial below it.

The *Top Metros* area contains statistical information, allowing visitors to see where their city ranks compared to other cities. The intention is to stimulate a healthy sense of competition.

The bottom of the screen is used for self-promotional purposes. It showcases selected volunteer organizations, current public service campaigns, or awards the site has won.

The top of the homepage is dedicated to finding and posting volunteer opportunities, the main tasks of visitors. Of less importance to visitors, but important to the company, is an editorial voice on the homepage. VolunteerMatch wanted to keep visitors involved by keeping them abreast of what the organization is doing, so a short blurb highlighting news or other features is placed just beneath the fold. Interested users can easily find it by scrolling down, but it remains out of the way of others with more pressing concerns.

Below the fold, there is more dynamic content. Once a visitor has used the ZIP code search, the program will use that information to assemble a customized page for that user. He or she will see up to five *Upcoming Opportunities* (with the option to view more, if available), or the user will be shown links to further information. Lists of Web site addresses (URLs) for national nonprofit organizations also adjust automatically by ZIP code so users can easily locate local chapters.

NERVE.COM

<THE COMPANY>

Launched in 1997, Nerve.com began as a content-focused Web site featuring "frank talk about sex and artful nude photography" for a sophisticated, urban audience. The company has since expanded its online and offline offerings to include a magazine, anthologies of fiction, a TV show with HBO, movie development deals, and a forthcoming book called *Big Bang: Nerve's Guide to the New Sexual Universe*, to be published in 2003.

<THE SITE>

It didn't take long for the decision-makers at Nerve to realize that a strong sense of community was beginning to develop among readers of Nerve's online content. Says Emma Taylor, Vice President of Community Development, "We were receiving an incredible amount of very intelligent feedback about the site and the subjects it raised, and it made sense to allow these smart readers to say these things to each other."

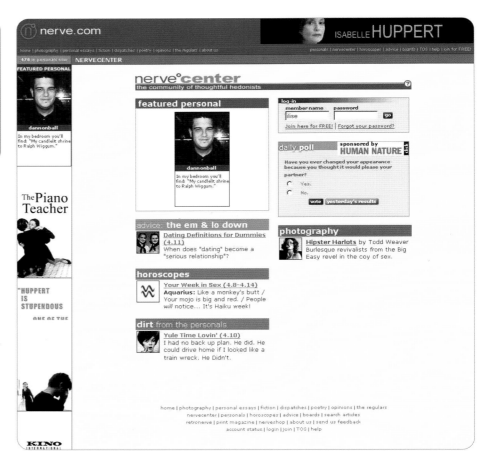

So in late 1999 the company launched NerveCenter, with the tagline: *The Community of Thoughtful Hedonists*. Nerve co-founder Rufus Griscom calls the site "an eBay of people" and "a high-end flirting environment." The community offers a smorgasbord of services from lively message boards to advice columns, but the mainstay of the site is *Nerve Personals*—the company's single-largest source of revenue as of the end of 2001. As of March 2002, the community had 740,000 registered members.

Creating or simply searching existing ads at *Nerve Personals* is free, but if you want to initiate contact, there is a per-use fee. The average user spends between fifteen to twenty dollars. *Instant Gratifier*, the site's instant messaging service, charges per thirty-minute interval, based on a credits system, to keep people connected live.

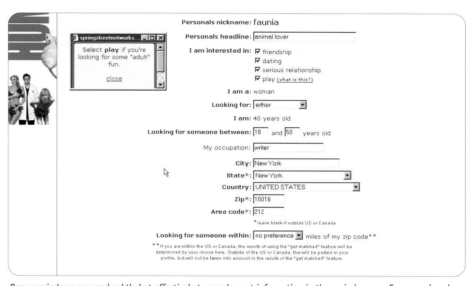

Pop-up windows are used subtly but effectively to supplement information in the main browser. For example, when a user tries to send an Instant Gratifier (Nerve.com's version of instant messaging), a window may appear to advise him or her that there are no credits currently available, but that additional credits may be purchased quite easily. Pop-up windows may also display terms and conditions without requiring users to leave the page.

<THE USERS, THEIR GOALS AND THEIR TASKS>

What can be said about the visitors to *Nerve-Center*? They're smart, hip, savvy—and maybe a little lonely. Although they're comfortable online, they're not necessarily Web experts. The majority are merely interested in meeting like-minded people.

NerveCenter's system requirements are minimal: Internet Explorer 5.0 or higher, enabled JavaScript and cookies with a minimum 28.8K modem.

"The original design idea for Nerve.com was a comfortable and elegant living room with a boudoir feel," says Joey Cavella, Design Director for Nerve.com. "I pictured red velvet curtains and warm tones. *NerveCenter's* pages are never generic white, but a parchment cream framed with deep red, like virtual velvet curtains."

Because *NerveCenter* is a place to meet people, it has to feel warm and friendly—like a place to hang out, not a place to shop for computer parts. "The personals can't feel impersonal," says Taylor. "That's why we use photographs of people's faces in very warm colors."

Appropriately for the site and its users, the language—for everything from advice to the help pages—is informal, friendly, and even a little irreverent. Sometimes the instructions sound like the voice of a close friend who really wants you to find someone. Explaining how to make a collect call, the site offers a little friendly advice on how to get your collect call accepted. For example, you're more likely to get a response if you've included a lot of information in your personal ad and uploaded a photograph, so other visitors will know you're worth responding to.

One of the things that makes *NerveCenter* user-friendly is the abundance of clearly written, concise definitions and instructions. For example, users creating personal ads are asked to choose the kind of relationship they prefer from among four options: *friendship*, *dating*, *serious* and *play*. In this context, play could mean a number of things. To avoid confusion (and possibly a lawsuit) the Web site provides a tiny text link right next to the word *play*. This activates a pop-up window, which then defines the term for perplexed users.

The search function is crucial on any Internet personals site. Nerve lets you search by gender, relationship type, and locale as well as by the more superficial attributes of height, weight, hair color and astrological sign. The advanced search option probes more deeply, so users can search by spirituality (religion), by common interests (based on other sites users visit), by looks (ads with photos only) or by urgency (who's online now).

Alas, on a site where so many words are allowed, and so many ads are posted by people who like to write, there's no keyword search option; so you can't find another Philip Roth fan unless you stumble across him (or her). This type of text search is in development and is scheduled for inclusion in the next version of Nerve Personals.

After you've logged in, the console appears at the top of each page. This dashboard keeps you abreast of all important occurrences in the personals section, including how many people are online, whether you have any new messages, and who is on your "hot list." It even tells you, by means of a little flashing icon (the only flashing done on the site, by the way) whether any of your favorites are currently online—a very seductive feature.

Cool, hip elements and retro black-and-white photographs convey the sense that Nerve is not like other personals sites. The homepage for this section also features four photos and quotes from cool, smart, good-looking people—real users of the site's personals section.

Content that supplements the personals, such as links to dating advice, love and sex horoscopes and "dirt" is located below the fold, because it's of secondary importance to the ads themselves.

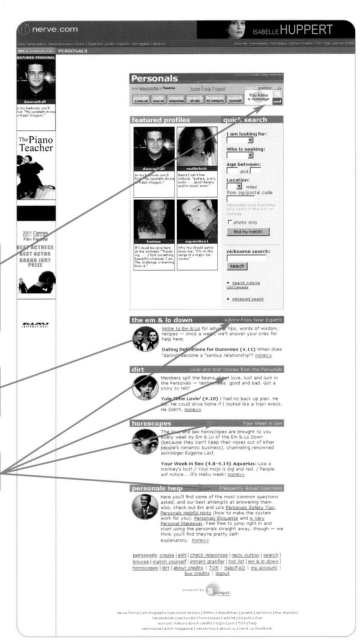

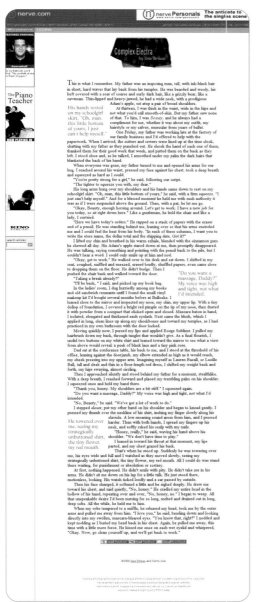

On Nerve, content gives rise to connection. There is a feedback button with contextual links at the bottom of every article and photograph gallery, so readers can immediately post feedback and browse through what others have said. Connections result as visitors reach out and respond to a story, article or essay with their own comments.

Unlike the personals at the back of a print newspaper, online personals are not constricted by space. Although there is a limit to how much you can write about yourself in your personal ad, you are allowed (and encouraged) to fully spell out words and to write coherent sentences, the better to convey the real you.

DESIGN FOR COMMUNITY

Original site

Site type: Online discussion forum

Site: www.designforcommunity.com

Site design: Powazek Productions,
www.powazek.com.

<THE PERSON BEHIND THE SITE>

Derek Powazek is a writer, Web designer and
"Web community consultant."

<THE SITE>

Designforcommunity.com was launched in
July 2001, one month before publication of
the book, *Design for Community* (New Riders,
2001). The site presents excerpts from the
book, new essays, and discussions related to
the topic. The community has a few hundred
members—a few dozen of whom actively
discuss current events relating to the design
of community spaces online, as well as issues
that arise in their own sites.

<THE USERS, THEIR GOALS AND
THEIR TASKS>

Although Powazek has never done a formal
survey, he can make a few assumptions about
the members of his community: they are
adults who use computers at work, so they're
usually on high-speed connections (although
the site doesn't require it). Most of them
probably work with computers for a living, so
their Web savviness and sophistication can
be taken for granted.

Powazek chose a color palette of warm reds and oranges that evoke the same welcoming feeling as the cover of the book, providing consistent branding as well as atmosphere. Illustrations from the book (by artist Claire Robertson) are also used on the site. Says Powazek: "Illustrations are effective in community spaces because they allow visitors to see themselves in the people more easily than with photographs. They're very humanizing."

In *Design for Community,* Powazek states: "We should design spaces that are friendly, that have clear and consistent navigation, that welcome new users and provide help mechanisms where needed. We should listen to the feedback we get and try to improve over time." Let's see how he does that on his own site for connection seekers.

To facilitate discussion, which is the site's main objective, Powazek practices what he preaches in the book, employing his personal voice, a clear navigation system, and a strong link between the content and the community.

"In the book I strongly advocate a close connection between your site's content and the community features where people discuss it. That connection is expressed architecturally (easy interlinking from one to the other) as well as in design (one looks and feels like the other). This is important. When you force your users to go discuss your content in a place with a stripped-down, or simply different, user experience, you're communicating something: You are not as important as the rest of the content here. It's like being forced to go sit at the kids table."

One of the challenges of a community-oriented site is motivating new users to participate. Powazek recommends looking at the site through their eyes as much as possible, and conducting tests to find out what may be intimidating to newbies.

On his site, Powazek pays close attention to signage and help text—and those places that are without it. One mistake community sites frequently make is burying the answers to all the questions members ask in a Frequently Asked Questions (FAQ) page somewhere. Powazek's site answers questions in context, where they get asked. For example, a new topic page addresses the questions brought up by starting a new topic, but avoids crowding the page with too much instruction.

The homepage offers clear, simple navigation to peripheral information about the book (and of course a link to buy it), but the conversation—clearly the main event—takes center screen. Powazek uses visual cues to show who is speaking. In this case, the division is architectural. On the site's homepage, it's clear from the formatting and location (and the use of the first person) that the author is speaking. The navigation bar on the right lists the last five conversations under the header *Recent Conversations,* and sets the section clearly apart with a colored background.

The first time visitors go to the conversations area, they are greeted with a simple introduction that welcomes them to the space. When visitors log in on subsequent visits, the site uses cookies to remember who they are so the introduction doesn't appear again. "It's little things like this that can help new users make the transition into communicating in a virtual space," says Powazek.

Members can post to the conversations area, which is one click in and formatted differently from the homepage. Besides the conversations header that appears at the top of the screen, subject lines are colored (like e-mail) and appear with attributions. The conversations area also comes with a new line of navigation elements (start topic, edit profile, log out) to indicate that the user has entered the discussion area.

On Designforcommunity.com, every content section ends with a direct question to the user, which then links to a discussion thread dedicated to the same subject.

Each posting ends with an attribution to a member of the community, complete with a link to that person's profile page, and the date and time of the posting. This clearly distinguishes comments by members from comments by the author. Says Powazek, "I post there, too. And when I do, my name links to a profile page just like everyone else. Of course, mine has an illustration that matches the site, and identifies me as the author."

Archives Author Bio Best of Sources What is ...?

Bambino's Curse

Diary of a Red Sox Fan

Saturday, June 23, 2001

Just baseball?

In his column title "Days of Whine and Roses" from the 6/22 edition of *The Boston Globe*, sportswriter Bob Ryan gives Red Sox fans a collective slap in the face by suggesting that we are self-absorbed and are perennial whiners, indeed, he says the worst whiners in all of sports.

Whatever. That may very well be true. (Of course, once again, here is Boston sportswriter distancing himself from this attitude, although Ryan, after Shaughnessy, is probably the biggest doomsayer in

<THE PERSON BEHIND THE SITE>

In New England, being a Red Sox fan is tradition, like an heirloom handed down from generation to generation. Edward Cossette took this for granted while growing up there, but when he left to attend graduate school in Mississippi, it wasn't long before he began to miss his baseball team. (This was in pre-Internet days, so all Cossette could do to relieve his craving was subscribe to *The Boston Globe*.)

Since the advent of the Internet, it's been much easier for Cossette to follow baseball from wherever he is in the United States—

Major League Baseball has made all games available as webcasts on the Internet—but that still didn't satisfy his need to stay connected to other fans. That longing, combined with the desire to write about something he loves and to design a site from the ground up, inspired Cossette to create www.bambinoscurse.com, which launched on April 1, 2001—baseball's opening day.

<THE SITE>

This site is a Weblog (or blog, as they are sometimes known): a public diary posted on the Web.

Site type: Weblog

Publisher of site: Edward Cossette, multimedia developer

Site: www.bambinoscurse.com

The content of Bambinoscurse.com is part confessional diary (how Cossette deals with the ups and downs of the Red Sox baseball season), part statistics (and the requisite facts that make baseball baseball), and part links to stories and articles about the Red Sox. Visitors to the site comment on Cossette's daily writings, forming a thread (or dialogue) of sorts.

<THE USERS, THEIR GOALS AND THEIR TASKS>

Fellow fans make up the majority of visitors to bambinoscurse.com: other "expatriates" looking for the connection that Cossette was missing. They span a wide range, from teen Red Sox fans needing help with term papers to senior Red Sox fans just getting online.

Cossette has kept design features to a minimum, and he's clearly proud when he says, "It degrades all the way down to Mosaic (the original Web browser)." What he means is that no matter what browser you're using, whether it's ancient or completely up-to-date, you get all the content clearly.

While there are many other Red Sox forums on the Web, they tend to fall into two camps: the highly esoteric world of statistics, and sounding boards for fan frustrations, resembling the banter one might overhear in a Boston pub.

Bambinoscurse.com offers a far more personal experience, with little focus on statistics. The structure of the daily posting doesn't offer much opportunity for long agree vs. disagree threads. Instead, the atmosphere is more confessional; hence the tagline, Diary of a Red Sox Fan. "In that sense, Bambino's is a place where I bare my soul and where others can follow my lead and do so as well," says Cossette.

Frequently, baseball and the Red Sox are but a starting point for reflection on the human condition in general. For instance, a recurring theme of Bambino's Curse, in both Cossette's writing and in the comments and e-mails from readers, is the emotional tie between baseball, fathers and children. "Many of us feel a poignancy of nostalgia and a realization that we are often the most comfortable and happy with our dads when we discuss the Red Sox," says Cossette. "As far as I know, there aren't any other baseball sites dealing with the baseball *gestalt*, if you will."

The opportunity to comment is open to everyone. No registration is necessary, but Cossette does reserve the right to remove any comments that he deems offensive or otherwise unworthy of publication. Fortunately, this is a rare occurrence.

Cossette generally posts his thoughts once a day, but on occasion he'll have two or three postings. Readers leave comments in response to that day's posting. "What never ceases to amaze me regarding the comments," he says, "is how well-written and insightful they tend to be. Whether a fellow fan is agreeing or disagreeing with the view I expressed in my daily column, I always come away with a bit more wisdom and respect for the readers."

"It's pretty amazing really. I'm not in the super-large community league where sites have ten of thousands of regular visitors and thousands of postings per day. When I started, I thought having ten readers would be a stretch. But the community grows each day by two or three people. On average, there are about two hundred unique readers a day, of which 150 to 170 are 'regulars,' visiting almost every day. Of that group, there are about twenty hard core posters who e-mail and/or post a comment at least once a week. Yet this number, too, seems to grow daily, especially as the start of baseball season approaches."

The pages on bambinoscurse.com are extremely light by design—the homepage is a mere 16K with Babe Ruth's face in your face—so even someone using a slow 14.4K modem can access it quickly. The background is clean and uncluttered, with lots of white space. The line height is twenty pixels, making it that much easier to read, which is good for everyone, but especially for seniors.

The most visually interesting aspect of the site, which Cossette believes he wouldn't have had a chance to experiment with in his day job at ExploreLearning.com (see chapter two), is the use of cascading stylesheets to make the evil eye of Babe Ruth inescapable. His face stays on the left side of the screen wherever you scroll, up or down. Cossette says this represents the connection of Red Sox fans who feel the curse. (Many consider the disappointing performance of the Red Sox after the departure of Babe Ruth in 1920 to be caused by "The Curse of the Bambino.")

Although the site is designed for Red Sox fans who are familiar with the content, those who stumble onto the site for the first time should be able to understand easily what it's all about without too much trouble. The addition of the unusually placed navigation bar in the top right corner of the screen resolves what was originally a confusing usability issue.

Cossette takes advantage of the alt text and title tags to give a little more information about where the link goes, kind of like a footnote.

Even when visitors are making their comments, the Babe's face is there. The script for the pop-up box is written so that the window fits neatly into the upper left-hand corner of the screen, just above Ruth's head. A pop-up window makes sense here, allowing visitors to keep what's underneath in view.

WHAT GOALS DO TRANSACTORS HAVE?

■ To streamline daily tasks like banking by using online services

■ To monitor and maintain personal and professional data

Bob Bowdon

Demographic: Male, 38, single

Occupation: Television reporter

Personality traits: Moderate technophile

Online habits and behaviors: "I go online fifty times a day. My work computer is connected via a local area network (LAN) connection, so it's always active, and I'm always using the Internet. At home I have a 56K modem."

Web history: "I was an early adopter. I was visiting usenet newsgroups (one of the precursors to the Web) in the 1980s while working at Bell Labs."

Favorite Web sites: drudgereport.com, ameritrade.com

Usability pet peeves: Too many steps to do something that could be streamlined, sites that require personal information, and of course, pop-up ads.

How do you search? It's a mix. For corporate information, I'll just assume the companyname.com, and see if it works. I also enter words on the Netscape address window (where you'd normally enter a Web address) and just use the browser-based search.

What are your typical online goals? "To communicate and transact. The best time-saver is Online Billpay. There's no question."

TRANSACTORS

If ever there were task-driven users, it's those who have embraced the Web as a way to take care of business. These users have taken activities such as paying bills, trading stocks, buying gifts and checking cell phone usage online, because it is more convenient and efficient.

Initially, transactors were the technology-confident early adopters who liked the autonomy and convenience offered by the Internet. They appreciated the ability to take care of business at any time of the day or night. They took time to personalize their chosen sites, making a commitment to them even if they were clunky and confusing. Today this group also includes individuals who are not as sophisticated. They will agree to take these highly personal and important activities online only if it's easy and painless, and if they feel secure. They need more support and instruction than early users did, and they need a site they can trust. Trust, in turn, is promoted by ease of use.

Both groups of people appreciate a clean, uncluttered design that guides them exactly where they need to go in order to accomplish their goals. Keeping clicks to a minimum, eliminating unnecessary options, and using clear language all help to make the user's experience pleasant and frustration-free.

Transactors may include individuals preparing or actually submitting their taxes online at H&R Block, investors doing all their banking online, or even truckers with an empty van looking for something to transport at transportation.com

H&R BLOCK

<THE COMPANY>

For years H&R Block has been strictly a main-
stream retail outfit—the place you go to get
your taxes done. The company has 20,900
franchise and company-owned offices world-
wide and eighty percent of all Americans can
find an H&R Block office within ten miles of
their homes.

<THE SITE>

As part of an ongoing expansion, H&R Block
has moved beyond the seasonal tax prepara-
tion business and now offers year-round
financial services. Their Web site and Web-
based products make this possible.

<THE USERS, THEIR GOALS AND THEIR TASKS>

H&R Block targets middle America; but
although users of its Web site are not
necessarily the first ones on the block with
the newest gadget, they are still more
upscale than the average taxpayer. Their
hardware and software is mainstream,
following the current average standards.

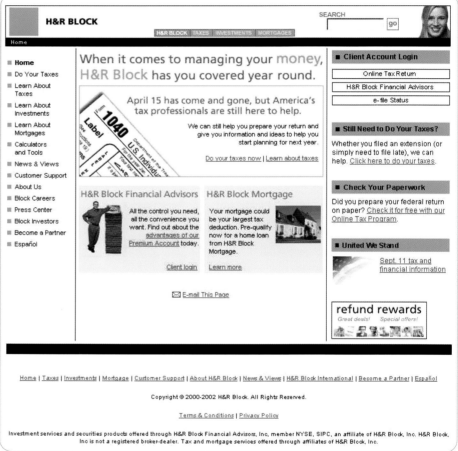

Ninety-four percent use Internet Explorer and many users dial up from both home (56K at best, maybe even 28.8K) and from a higher speed connection at work. The most recent H&R Block homepage is a mere 28K. It's also Javascript-based, and has few heavy images.

Most visitors to the site are task-oriented. They can buy tax software, find a tax tip, get the answer to a question, download tax forms, or use the tax calculator to find out how a life event or changes in the tax laws will impact them financially.

<GOAL OF THE REDESIGN>

Two goals of the ongoing revisions to the site include making the extensive content and resources not only accessible and visible, but letting visitors know that H&R Block is not just taxes anymore.

The three-pod structure of the original site offered sections for each business unit— taxes, investments and mortgages—that were accessible from the homepage. Customers, however, tend to think about their finances not in terms of business categories, but in terms of their needs at various stages of life. Developers for H&R Block decided to reorganize the site according to the user's point of view. So, for example, investment options are no longer grouped by type of investment, such as mutual funds and IRAs; but by personal concerns, such as changing jobs, saving for education, investment planning, and retirement. It's a mere shift of perspective, but extremely important.

Usability testing also gave the team insight into how each section should be named. Corporate insiders may identify products and services by names that either mean nothing or suggest something different to customers. For example, on one of the early iterations of the site, they used the phrase *File your taxes with H&R Block* which was misinterpreted by users as *let H&R Block file your taxes online*. Eventually the description was changed to *Do your taxes*, which was clearer and more in line with the actual services offered.

"You have to build a site for all the different ways people work," says Meleah Gearon, User Experience Planner. "H&R Block has done an incredible job at not excluding any types of Web users. Because if people can't get around the way they want to, they won't bother."

Ric Moxley agrees. "That's the value of doing usability testing. Some users don't get the things that appear to be so obvious to those of us on the Web team. You can look at logs and numbers...you won't find out so much. If you take the person, the actual user, out of the picture, you're missing the piece that's driving the whole process."

The old site had a lot of images that made the page download very slowly (all the words in the center squares are actually images).

HOW PEOPLE USE PASSWORDS

Poor password usability can ruin your Web registration process. While passwords are a painful fact of life, there are ways to minimize the problems that users face. It's important to understand how people use passwords. Remember this about your users:

They aren't sure they're alone. Many users are at work, or school, or somewhere else where they can't be sure if someone is looking over their shoulder as they type in a password.

Their passwords depend on personal information. When you're sitting there in front of a registration form it's difficult to come up with a totally random password, so most people cast about for familiar words and numbers related to their life, their families, even their favorite TV shows.

They use one password for everything. Scary but true, the vast majority of Web surfers try to use the same password wherever they register.

Users hate typing in passwords. They will almost always choose a "Save my password" option if it's available.

By Joshua Ledwell, Senior Producer for Direct Marketing at Terra Lycos. Published on www.webword.com

Although this version has fewer heavy images, viewers tended to gravitate toward the straightforward text links on the right rather than the image links in the center (the pig and the house). In the new version, the team decided to change these to text links.

In the revised contextual navigation, the left nav bar focuses specifically on the content of that section—in essence, taking the second-level navigation from the homepage and making it the first-level navigation for the section pages. A thin black bar on the upper left, just under the logo link, is the home of the bread-crumb navigation. A breadcrumb trail is necessary for a site with such rich content, for orientation as well as easy navigation from one section to another.

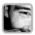

BETTER ONLINE BANKING

Banks have been using machines to interact with their customers longer than almost any other industry, and for the most part, people are comfortable interacting with computers for their banking needs. ATM machines are ubiquitous, and they work because they are simple and clear. But people are still nervous about managing their money online. Maybe that's because there are no dollar bills to stuff into your pocket, no check to scribble on and slip into an envelope. Double click on the submit button while paying your bills online and you may have just paid your cable bill twice. Oops.

That didn't matter to the early adopters of online banking, who were Web-savvy, self-directed and willing to stumble through clunky sites in exchange for autonomy and convenience. But according to a June 2001 article in *Bank Technology News*, growth rates for these savvy customers have peaked. The next wave of users are older, less self-directed, and less comfortable with technology, which means they require more guidance, more instructional text and more supportive hand-holding than is currently available on banking sites.

Why is online banking so complicated? Jason Fried, a founder of the Chicago-based Web design firm 37signals, thinks it's because most online banking sites have featuritis—too many useless features that complicate the interface. Most of these seem to be motivated by the bank's desire to add something that a competitor's site doesn't have rather than by a desire to help users. In fact, as reported in Bank Technology News, "Forrester Research interviewed executives at 30 banks and brokerages and found that Web strategies are dictated largely by business goals, such as the retention of existing customers, and by efforts to enrich the online experience at the sites, both to aid in customer retention and to attract new business." In other words, the goals of these sites are not to facilitate the user's experience.

We have seen that features should be motivated by a user-centered design process, of course. So what does the user need? BetterBank is 37signals' answer to that question.

The designers at 37signals spend a lot of time using the Web. Like everyone else, they want to save time and make their lives easier; so when they come across a site that does just the opposite, instead of surfing to find another site, they simply rebuild the interface the way they think it should work, then post it on their own site. That's what they've done for online banking sites.

Most online banking sites are multi-sectioned, with no functionality and no information about a user's account on the homepage. If you want to see your most recent transaction, it is usually at least three clicks away. On BetterBank, everything you need to know or see is all on one uncluttered page.

Users taking care of business online are extremely task-driven. That's why BetterBank has virtually no graphics. Says Fried, "You don't want the interface to ever detract or distract from the information. Let the content shine, not our design." For lightning-fast loading no matter what the user's connection speed, it's ninety-five percent html.

BetterBank is a one-page Web site that serves as a financial dashboard, offering everything a user needs to do or know, with jumping off points to other tools and activities. Because not every user needs to see the same thing, BetterBank hands control of the layout over to the user, who can open and close, expand and contract modules according to his or her needs. Close up, the boxes on the left are made of dotted rather than solid lines. Dotted lines offer a softer way of bracketing information, reducing the visual weight of the interface and making it almost transparent. Also, the technique extends the range of available colors beyond the Web-safe palette—the gray dot and white space create the illusion of a lighter gray that isn't available in the 256 palette.

TRANSPORTATION.COM

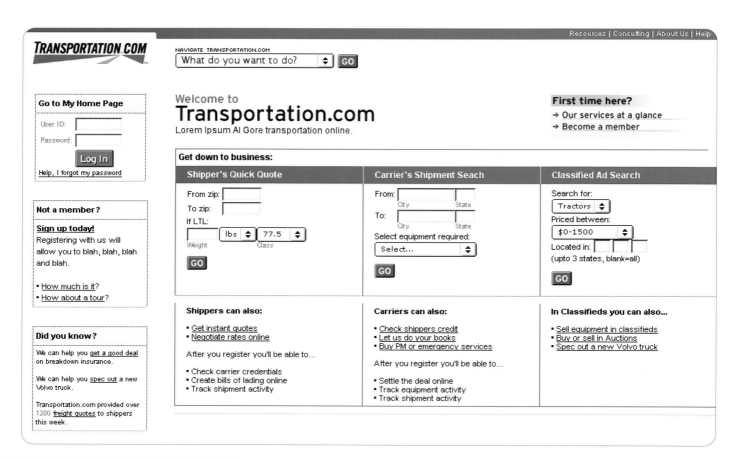

<THE COMPANY>

Yellow Corporation, one of the largest transportation companies in the United States, is the owner of this online freight brokerage, which transports at a regional, national, and international level.

<THE SITE>

Established in January 2000, Transportation.com is a business-to-business transportation marketplace for shippers and carriers. In plain language, when someone ships using Transportation.com, the site acts as a broker, paying the carriers and invoicing the shippers.

<THE USERS, THEIR GOALS AND THEIR TASKS>

There are two user groups: truckers and shippers. The truckers are on the road, often computing from truck stops. They are accustomed to using their voices and their Citizens Band radios to get things done, and they don't have a lot of time. Often they don't have a reliable Internet connection, and most are not very Web savvy, so a site for them has to be as fast and useful as possible.

The shippers, on the other hand, are more computer-savvy though not necessarily Web-savvy. They sit at desks where higher-speed connections and relatively mainstream hardware and software are available.

<GOALS OF THE REDESIGN>

The initial intent of Transportation.com was to provide tools for truckers, who don't have time to deal with the paperwork and "admin-istrivia" of shipping. But the company gradually began focusing less on the needs of carriers and more on those of the shippers, according to Jason Roberts, Manager of Information Solutions for Meridian IQ, a sub-sidiary of Yellow Corporation, "Shippers have the money and make the decisions. Carriers are service providers." The purpose of the site is to bring both groups together so that both can benefit; so although the focus on ship-pers dominates the design, the needs of the carriers must also be taken into account.

The semi-public prototype site was being used by customers before it officially launched. That's when Transportation.com hired the Chicago-based Web development firm 37signals to redesign the site in line with preferences expressed by these early users, essentially usability testers.

The original homepage was a traditional welcome page, with descriptive text about the site and navigation buttons leading to different tools and sections of the site. Feed-back from early customers made it clear, how-ever, that the site was too complicated. They didn't want or need a welcome page. They wanted to be able to get something done on the homepage, not waste a click to get there. "We heard things like 'Why use the Web if I can just use the phone?'" says Jason Fried, a partner at 37signals. "So, the key was offer-ing useful services online that couldn't be available offline. We had to add value."

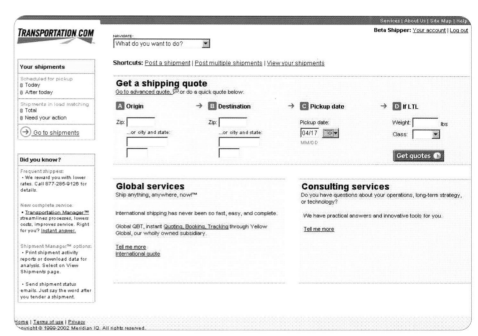

To get a quote, a visitor enters specifications.

<VISUALIZING A PROCESS: GETTING A QUOTE>

In the transaction process, every minor glitch carries the potential risk of losing the customer. To minimize that risk, designers should carefully polish each step along the users' path, considering the customer's prior experience, habits and expectations.

On Transportation.com, shippers go through a five-step process to get a quote. The objective is to make this process lucid and self-explanatory. All the interior pages of Transportation.com are functional. As on Amazon.com, once users are in the buying process, anything that may distract them from buying is removed. Links to company information are available, but subdued. The text is limited to the essentials and is used to provide supportive content and instruc-

tions for those who need it, as well as error messages for when something goes wrong.

Although users appreciate reminders of where they have been, and previews of where they are going in the transaction process, their primary concern is where they are now. Too many sites clutter screens with information that obscures the task at hand. Designers must keep users visually focused on what they need to do before moving on.

Step 1

The focus of the homepage—and of the entire site—was shifted to the number one task for which users come to Transportation.com—getting a quote. If a user wants to do some-thing else, a pull-down menu at the top of the screen, under the instruction *Navigate*, asks *What do you want to do?* and provides eleven different destinations.

Step 2

The user then selects a suitable carrier based on the previously entered information.

Step 3

Once the choice of carrier is made, the user completes the bill of lading. Many of the fields are pre-populated with information they have already entered, earlier in this transaction or in past transactions.

Step 4

This screen is designed to mimic the familiar paper version of the bill of lading, which is a legal document that must accompany a shipment and which shippers usually fill out by hand. Online forms that are consistent with the offline documents to which they are accustomed help users feel more comfortable using an electronic medium. Two buttons at the bottom of the form allow users to choose where to go next. Because most users will be ready to proceed to the next step, that button is larger and brightly colored. The few who may need to go back a step can do so by choosing a smaller, less prominent gray button. Throughout the process, blue indicates the regular route, while gray indicates a detour.

In the next iteration of this site, *Proceed to the next step* labels will be replaced with more specific terms that are consistent with industry jargon. For example, when a shipper selects *Tender*, he or she will know that the truck will soon be on its way.

Step 5

The bill of lading is complete and the final steps begin. The user can verify their order and sign up to receive e-mail updates if they wish.

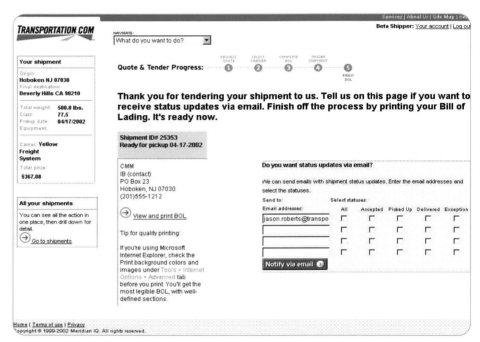

Step 5: *The status shipment box on the right is one of the users' favorite features. It not only allows them to receive status updates by e-mail; it also allows them to notify others—the recipient, the accounts payable department, or anyone else whose e-mail address they enter—about any status changes.*

<TYPOGRAPHY AND NAVIGATION>

Because most truckers care little about typography, the site uses as much HTML text as possible, to take advantage of a multitude of benefits: rapid loading, easier maintenance, fewer images, less bandwidth. The only GIFs on the homepage are the welcome banner and the banner ad in the upper right for frequent shippers. The rest is text.

Yellow highlights that appear when moused over cue less sophisticated users that underlined phrases are clickable links.

Step 4: *The HTML bill of lading appears in a pop-up window for easy printing.*

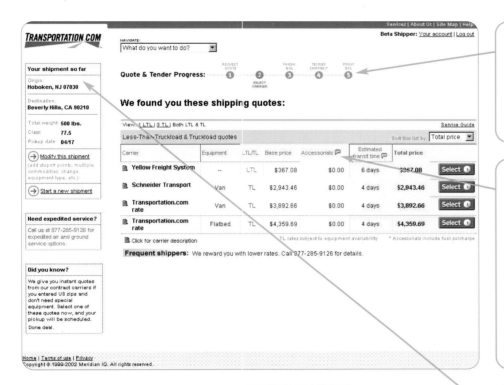

The process bar at the top of the screen displays the five steps as a timeline, with the current step shown below the others, so users can determine exactly where they are in the process. Unlike a breadcrumb trail, however, this process bar doesn't allow a user to move from step to step. It's simply a visual representation of the transaction process.

The talking bubble or information box next to any word or field indicates that there is an explanation available, but it does so without cluttering the page. Moving the cursor over the icon summons the brief appearance of a small box with a cue or explanation. This technique is especially appropriate for repeat users, who constitute the majority of the site's visitors. Pop-up windows could have been used, says Jason Fried of 37signals, but "we saw people who didn't know how to close the window, which is frustrating for them because it pops up in front of what they're doing. Plus, a pop-up window is overkill for something that is only a sentence or two."

Instead of a navigation bar, the left side of the screen holds a box labeled *Your shipment so far*. This tracks the user's progress through all five steps, giving feedback and recording choices, similar to an online shopping cart.

Basic User Interface standards governing page layout, navigation, typography and images are maintained across the parent company's brands. The only major difference on Yellow Global (www.yellowglobal.com), a subsidiary of Meridian IQ, is the addition of the color orange.

\<TRANSPORTATION.COM STYLE GUIDE>

The team at Transportation.com put together a style guide to form parameters for any future iterations of the site, as well as for their general knowledge. The guide covers general topics such as color, typography and general design tenets, as well as more specific information related to their particular site. For example, there are explanatory sections for "when to use the dominant blue button" and "when to use the secondary gray button." This style guide helps keep the site consistent and usable.

DESIGN FOR WHEN THINGS GO WRONG

It's impossible to be perfect, so make mistakes well. That is the essence of contingency design (i.e. design for when things go wrong). No matter how much testing and quality assurance has gone into a Web site, customers will encounter problems. Contingency design features include error messages, graphic designs, instructive text, information architecture, backend systems, and customer service that helps visitors get back on track after a problem occurs.

Here are three rules for providing successful contingency design. Applying these rules can dramatically improve a site's performance.

Reduce the need for constant back-and-forth between pages to fix errors. Whenever possible, collect form errors and display them on a page where customers may fix them without backtracking. If a form error occurs, redisplay the same form with the errors clearly highlighted. Alternatively, accept the valid information entered and show customers a page where only the problem field is displayed.

Use highly visible color, icons, and directions to highlight the problem. Web pages are a confusing jumble to most customers. If there's a problem spot (e.g. the phone number has too many digits), clearly identify it so it's easy for the customer to find. Red text, an error icon, and explanatory text should all be used.

Don't block content with ads. Sites shouldn't block critical content with ads or promotional offerings. This is even more important when error messages and other problem-solving devices are involved. Ad revenues may be essential, but sites will lose money if annoying ads drive customers away for good.

For more rules, see www.designnotfound.com, a collection of real world examples of good and bad contingency design, published by 37signals.

USER EXPERIENCE RESEARCH: WHAT IT IS AND HOW YOU DO IT

Once a prototype has been built that is robust enough for target users to try out on their own, we suggest conducting research that enables them to do so. The reason we call it user experience testing as opposed to, for instance, "usability" is that this research is designed to have people experience your site. It is not sufficient in this competitive arena for a site to be merely usable (that is, navigation-friendly). Sites must also provide experiences that are compelling and that do a better job of delivering what they offer than other options available, be they online or offline. We recommend conducting one or two days of research, which means eight or sixteen interviews, each of which should be roughly one hour in length.

The major concept behind user experience research is that individuals will be empowered to experience a company as intimately on their Web site as they would in the real world. Accordingly, the goal during the hour-long interview is to see how a user experiences your site so that it can be refined in ways users will appreciate. If a user wants to search for a pair of pants and shirt that match as a gift, he should have the option of doing so. Likewise, if he would buy or sell steel on the site, he needs to be able to do that, too. The following are typical of the goals companies seek to achieve by conducting user experience research:

■ *Grab their attention with an effective homepage.*

■ *Establish a tone and manner that is consonant with their expectations of your brand and your industry.*

■ *Empower users to easily and intuitively travel the pathways of your site to accomplish their goals.*

Some Rules of Thumb

Regardless of the approach you take in your research, focus groups or user experience testing, the following are some additional guidelines to keep in mind.

Again, look for a firm that has experience in your company's industry because this will give you the benefit of learning from other people's experience. And while some companies are a bit nervous about doing so, we recommend it. Any firm that has worked on three other trading sites or several education or healthcare or gaming sites will have gathered a lot of wisdom in the category about how to define the target audience or structure the interview, and this can only be of benefit in the design and structuring of your Web site.

If you are not testing your current "live" site, try not to schedule research until you are certain you have a prototype that is robust enough not to "blow up" on users or frustrate them with its incompleteness. Even if they can buy only one sweater, permit them to travel the entire purchase path. Doing so will provide you with valuable insight into the shopping experience. In contrast, scheduling testing prematurely results in money wasted in cancellation fees, or in the testing of a site that is simply not ready to be viewed.

This being said, understand, too, that the site need not be all but ready for launch when it is tested. In fact, if it is too polished, there may not be time or money to fix what testing reveals is broken. To be effective in testing, functionality should be the paramount consideration.

Populate the site with enough content and functionality to simulate the experience you want to test. For an information site, this might mean loading the prototype with articles; for a finance site, it might mean populating it with a sample account so that users can see what their real account might look like.

Again, don't do thirty interviews (a clear case of overkill when it comes to user experience testing). We've found only three reasons to do more than eight (or at the most sixteen interviews):

■ *If you have three or more significantly different target audiences: for instance, parents, educators, and kids, or brokers, doctors, and patients.*

■ *If your development allows rapid prototyping, which enables you to make changes between days of testing and, therefore, rapidly enhance your site within a day or two of research.*

■ *If your site has so much functionality that the number of pathways you need people to travel is more than can be covered in a day or two—even if the tasks you give people are rotated.*

Don't give people more than three to five tasks to accomplish. Remember, the goal is to simulate reality, not to create an endurance test.

Phrase the tasks you give people in "plain speak," and be careful not to employ the same words used on the site. In this way, people understand what you are asking but are not led directly to the button you are testing.

Unless you are AOL or an ISP that is targeting those who are new to the web, don't waste your time interviewing what some call "newbies." Those who have never searched or browsed are not going to give you much useful feedback about your site. Even if you are an e-commerce site, split your interviews between experienced e-shoppers and those who are merely open to the idea. We believe that you will learn a great deal about your site from those who have shopped on many other sites.

Structuring a User Experience Interview

While each project has its own unique objectives, we have developed a basic approach to the user experience interview that we use as a question flow for the interview guide. This basic flow, outlined below, is designed to gather initial impressions and expectations, as well as in-depth reactions, to content and functionality. And, of course, we've also built in additional probing on brand issues.

Before even showing the homepage, ask the participant what his relevant experience is on- and offline. How does he currently shop for a car? Get information about a disease? Decide which play to attend? This will enable you to understand his expectations and interests.

Gauge his gut reactions to the homepage. What kind of site does he think it is? Where do his eyes go first? What kind of people is the site for? Would he stay? And if so, where would he go?

Ask some users to simply do something they've told you they are interested in doing—search for a car, buy a gift, or register for a prize. Leave the testing room and see what paths they travel. (We recommend videotaping the interview "picture in picture" so the development team can observe the user's facial expressions and, in some cases, hand movements, along with the screen they are using.) Simply watching where they go is very useful, especially if the site is geared toward searching or shopping. It shows you how they would approach the task and how intuitive or circuitous the process is.

For others, drill down on each button and area of the homepage. Ask the user what he would expect to be behind the button. Learning that the button means five different things to different users, or that no one understands what the button means, tells you a lot.

Give each user a series of tasks to do that are in sync with what he would do in real life. We suggest three to five tasks, which can be less or more depending on the complexity and length of the task. Make a list of every path you want users to travel. Write tasks that take them there. Then, rotate the tasks you give people based on their interests and what you want to learn from them.

After (and sometimes during) each task, ask users what they are thinking. If they look confused, ask them how they are feeling. If they tell you they are confused, ask them to explain why and what might be different about the site (language, flow, placement, type size) that would mitigate this response and make the process appealing and easy. Ask them what words or images would make sense to them.

When you wrap up the interview, ask about their overall opinion of the site. If you were a fly on the wall, would you see them returning of their own volition? If so, why and when? How would they describe it to a friend? What three things would they fix? (Usually, what people remember at the end of an interview is what most needs to be fixed.) If the site is for an established brand, find out if the site met with their expectations of the brand. If not, why? How could it be fixed?

Making User Experience Testing Actionable

First, and perhaps most importantly, we recommend conducting a debriefing with the entire team immediately following research. Almost every team we've met will retreat and make changes within forty-eight hours of testing. By debriefing right after the research the minute it is over, the entire team is more likely to be focused on and agree about the major elements learned, and they will be able to brainstorm about what to fix and how to accomplish this. We often notice that the majority of fixes that come out of such meetings are implemented within days of testing, even before the final report is complete.

Finally, and on this note, in designing a final report of research findings, we think what you learn from user experience testing can be divided into three broad sections:

■ *Mindset of the User. In this section, describe the perceptions or behavior that shape what users expect of your site. These often impact how people experience it and how they interpret the meaning of labels. These are important to understand when you're fine-tuning your site.*

■ *Strategic Findings and Recommendations. In this section, describe the learning you come away with that impacts branding, positioning, or overall communication. These findings are often related to homepage design: how you describe your site, whether people think they need to register with the company in question, what they expect to do on your site, and so on. Making small changes on your homepage, such as reordering functions, changing the prominence of your logo, or using a visual metaphor to communicate what the site is about, can dramatically affect the way target users experience your site.*

■ *Tactical Findings and Recommendations. In this section, identify page by page or task by task, any problems that exist with respect to navigation and nomenclature and how to fix them. We find that the more concrete these recommendations are and the more informed they are by suggestions made by users, the easier the team can integrate them into Version 2.*

"User Experience Research: What It Is and How You Do It" (reprinted from *Back to the User: Creating User-Focused Web Sites*, by Tammy Sachs and Gary McClain, Ph.D., ISBN 0735711186, © 2002 by New Riders Publishing. All rights reserved.)

WHAT GOALS DO BUSINESS BROWSERS HAVE?

■ To dispense or gather information in a concise manner

■ To manage the needs of various people within an organization through online services

John Fix III

Demographic: Male, 42, married

Occupation: Retail hardware store owner

Personality traits: Friendly, inquisitive, generous

Online habits and behaviors: "I log on every day, numerous times each day for an average of about two hours per day. I have DSL at home, and a T1 connection at work. Work is noisy—it's a busy office—but at home it's quiet, because the PC is in a home office away from the television."

Web history: "I've been using the Web regularly since 1995, but using Internet e-mail since about 1992."

Favorite Web sites: www.theonion.com, www.fuckedcompany.com, ESPN.com, DejaNews.com

Usability pet peeves: Animated ads, pop-ups, code that disables the back button

How do you search? "On a Web site, I usually look for a search option if the item or information I'm looking for isn't immediately visible. I try not to get distracted by other info on the site. I use the back button all the time, usually via the mouse button (I use an MS Intellimouse Explorer)."

What are your typical online goals? "Hmmm, depends on what I'm doing. If it's something work-related, I want to get the info and then get back with my customer or employee. It's made things like finding product information for my hardware store much easier."

<chapter> 6

BUSINESS BROWSERS

When it comes to business-to-business design, some might say, "What design?" Often it's true that the focus is more on the functional rather than the aesthetic. Most business-to-business sites are developed as tools for improving processes, productivity and profitability, often at the expense of design. This is partially due to a fundamental difference between business users and consumers: to business users, utility is more important than appearance.

According to Steve Kafka, analyst with Forrester Research, "Business-to-consumer is all about getting consumers to spend time on the site so you can sell advertising or so you can cross-sell other products. But business-to-business is fundamentally about saving time."

Web sites that work for business browsers are clean, well-organized and focused primarily on delivering information to a customer with the fewest number of keystrokes or clicks. Whether it's a personal need or a business need they're seeking to satisfy, business users are usually on a mission to get something done, and business-

to-business Web sites must enable users to perform their jobs more efficiently.

Who is a business browser? It could be an architect looking for an engineering firm like FTL Happold, a manager at an international company looking for translation services at Berlitz, or a vice president of information technology getting ready to approve a software purchase for his company at a place like Deerfield.com or Tripwire.com.

Business Web users are savvier than ever and tend to ignore gratuitous eye candy or superfluous bells and whistles. And while they aren't always the final decision-makers, they are part of a decision-making process. The sites that work best for them support handoffs among the multiple people involved in researching, recom-mending, deciding, approving, paying and receiving the product. Before a single sale can be made, the sites must appeal to (and be used by) a variety of people with many different skills and interests.

TRIPWIRE, INC.

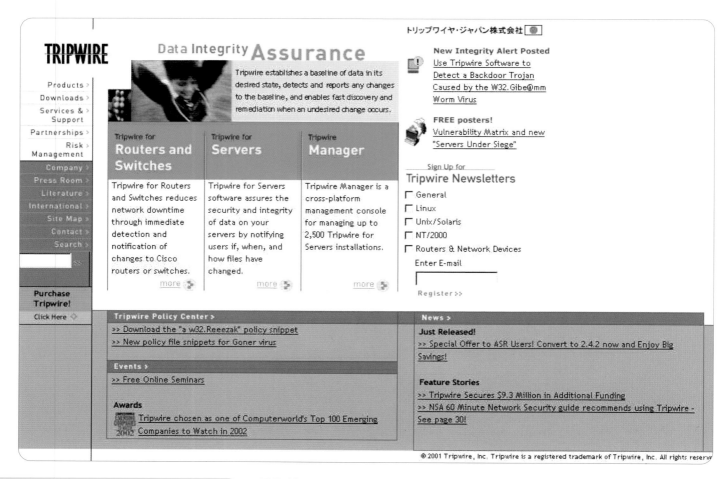

<THE COMPANY>

Tripwire Inc. is a Portland, Oregon-based company that sells business-to-business software for network management.

<THE SITE>

Because this is a promotional site rather than an e-commerce site, it offers lots of technical information about the software it sells. Tweak Interactive was brought in to do an evolutionary redesign on the one-year-old site, with Phase 1 focused on the homepage, and Phase 2 on the product section.

<USERS, THEIR GOALS AND THEIR TASKS>

Tripwire identified two groups of primary users for their business-to-business software: network administrators and information technology managers in corporations. (Three secondary groups include the media, investors, and people looking for Tripwire's Japanese site.) All users need to find information quickly, but each is looking for a different kind of information.

Homepage makeover

Company type: Software provider

Web site address: www.tripwire.com

Web design: Tweak Interactive
(Portland, OR)

Tripwire had already done a lot of research on their users, so Tweak Interactive developed user profiles based on that research. The primary users actually use the software, so they must be able to quickly and thoroughly understand how each product works and how it must be deployed. The site should provide users with product descriptions and installation requirements, access to support information, registration for regular updates via an e-mail newsletter, and a means of purchasing the product.

The IT managers and other users who approve these purchases don't need as much detail or technical information. Their task is to simply find top-level information and news, and to ascertain the company's trustworthiness.

Since there was no hard data about the technical constraints of any of these users, Tweak and Tripwire together made educated assumptions about business consumers in information technology: because they're in the industry, they are likely to have high-speed connections, up-to-date equipment and browsers, good screen resolution, and a high degree of Web-savviness.

User profiles developed for Tripwire.com by the Tweak Interactive team.

<GOALS OF THE REDESIGN>

The original site had a branding problem. Nothing on the front page told the user what the company does. Most of the screen above the fold was occupied by a slow-loading, black-and-white, out-of-focus photograph of a child playing, and just below that, the tagline. Suffice it to say that the relationship between the image of a child and electronic routing was not evident.

As this was an evolutionary redesign, Tweak couldn't make drastic changes to the look or Tripwire would have ended up with a front page that didn't work with the rest of the site. To ensure that regular users would still recognize the site, the graphics (the photo, the solid blocks and the tagline) were not eliminated, but minimized and reapportioned to convey a message.

The original Tripwire site had some serious usability problems. The most obvious and most problematic was that there was no clear way for primary users to find product information easily and quickly. Almost everything they wanted was located below the fold on a screen designed for 800 x 600 resolution. Indeed, it appears that no one even took the fold into consideration. Other than the navigation bar at left, no text and no links to other areas of the site appear until the visitor has scrolled down to the very bottom of the page. Even the *Purchase Tripwire* link is located below the fold, so someone ready to buy would have trouble figuring out how to purchase the product.

The original Tripwire site used a very large graphic element that took a long time to load, and there was no explanation of the company's function on the homepage.

One goal of the homepage makeover was to direct primary users to product information according to who they are and what they want, while providing the first level of information about the company and its products for secondary users. Most screen real estate is dedicated to making it easy for visitors to select their category of interest, then drill directly down to the information they need. Three content boxes briefly describe what each product does, then promptly send the user to the appropriate area to find out more.

The original navigation bar remains at left, but now the center of the screen emphasizes the products. The right column is used for self-promotion and lead-capturing devices such as the company's newsletter and promotional poster. Because Tweak was not charged with redesigning the site's global navigation, designers simply moved key links for lead-capturing devices, above the fold, and created representative icons to draw the eye to this information.

Next Tweak tackled the product section, striving to update the look and feel as well as to streamline the flow of tasks. Since the product section supports sales, it was logical to make it next on the revisions list.

Eventually, the revised look and feel of these interior pages will apply to the whole site as the team moves forward with the phased, evolutionary redesign. Until more of the site is redesigned, however, the product section will look markedly different from the other sections.

Revising a site piece by piece is not unusual for companies with strict budgets. "This is a risk, though," says Katherine Gray, owner of Tweak Interactive, "because users may find the transition between sections a bit jarring and the rest of the site will look dated—a branding 'no-no.' The upside is that once the client stakeholders see the improvement, they're more excited about revising the rest of the site."

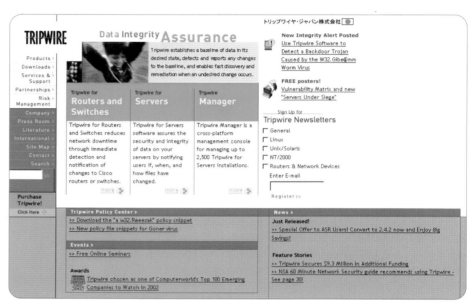

The new Tripwire site uses the same image, but it is much smaller and faster-loading.

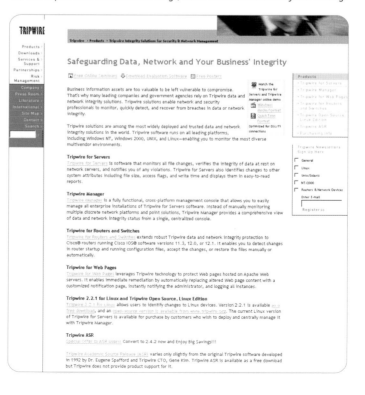

DEERFIELD INC.

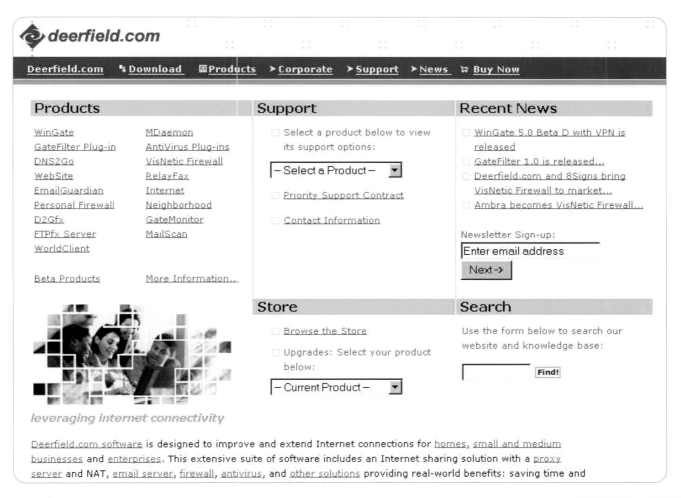

<THE COMPANY>

Deerfield, Inc. is a publisher of Internet software for businesses of all sizes: home offices, small enterprises and large firms. The company also produces some consumer software.

<THE SITE>

The goal of the site is straightforward: to sell and support the software that the company develops. The site itself was not simple, however. Deerfield, Inc. had no single Web presence, but instead was represented by a host of sites established by various divisions within the company. Some sites were devoted entirely to one Deerfield product.

Four redesigns in less than five years had focused on marketing needs. For version five (V5), the current iteration, the Web team—led by Geoff Brown, Director of Online Operations for Deerfield and owner of GVBrown & Associates usability group—decided to concentrate on branding and usability. The plan was to integrate all division and product sites into a cohesive corporate system.

Complete makeover

Company type: Publisher of Internet software

Web site address: www.deerfield.com

Web Design: In-house design team

\<THE USERS, THEIR GOALS AND THEIR TASKS\>

Although business users make up the bulk (65%) of Deerfield's users, a significant percentage (35%) are home users as well. So the Web presence Deerfield developed had to be appealing to the business user, welcoming to the home user, and usable for both. Research showed that while many users had high-speed connections, some didn't. Most users had 800 x 600 screen resolution, but some were limited to 640 x 480. Although it's common for Web sites to design for the majority, Deerfield wanted to be accessible to as many users as possible. The design team tried to keep the low-end user in mind.

Before V5, Deerfield had twelve separate product sites. The general structure of the sites was similar, but the style and personality of each was different because the content was produced by different people. There were no connections or links among the various sites, no continuous flow of information. Needless to say, it was difficult for users to go from product to product.

In addition to bringing all products under one umbrella site, V5 uses a breadcrumb trail and other navigation aids to facilitate movement from section to section. The trail originates from the main corporate site, showing visitors where they are in relation to other sections and promoting awareness of the corporation's complete product line.

A common usability problem in previous versions was slow downloading caused by voluminous pages. Few visitors were willing to wait up to thirty seconds long—even with quick connections—to access information.

Research on connection types helped determine standards for overall file size. Data for one home office product showed that over fifty percent of its users had either DSL, cable modem or an even faster connection, but data for other products indicated a higher rate of dial-up users. Deerfield didn't want to alienate dial-up users, or those in overseas markets where Internet connectivity is not as reliable as in the United States or the United Kingdom, so Deerfield set the aggressive goal of achieving a less-than-five-second load time for all pages. Guidelines called for every page (except the homepage) to weigh in under 10K.

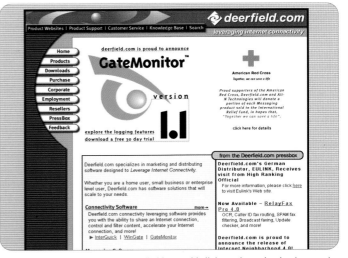

On the old site, navigation was handled by graphic links set in navigation bars at the top and left. Directions to the four main tasks were scattered around the screen, a situation that confused task-driven users.

The redesigned V5 is now considered to be one site, offering over three thousand pages of static and dynamic information. Each product still has its own subsite that users may access directly, but now these subsites follow a more consistent pattern.

The Deerfield team considered browser properties and utilization issues while planning the screen layout. Most users do not maximize their browsers during a visit to a site, so designers should gauge the actual available screen width in a browser window rather than just its resolution setting.

In an earlier revision, Deerfield implemented a version on its private site that used three-tier DHTML menus. However, it was soon discovered that people were having difficulty finding the products and information they sought because they were unwilling to dig through multiple navigation tiers. As a result, navigation in the V5 site was structured with only one drop-down level.

The connection speed presented a challenge, especially from the overseas users, who make up forty percent of Deerfield's audience. For example, when designing for the international market, it's important to remember that in some countries, users are charged by the volume of information downloaded, so a graphic-heavy site is more expensive for customers, and therefore much less desirable.

On the new site, the Deerfield team decided to replace the graphic links with text for two reasons. First, graphics take longer to load. Second, eyetracking studies had shown that more people are drawn to text links than to graphics. User tests confirmed the point: on Version 5, more people clicked.

To conserve bandwidth, Deerfield plans to gather all its associated local sites from around the world into one corporate basket. The design, therefore, must be executed in such a way that international partners can easily adapt content and navigation for their own locales. Because changing the HTML code is easier than editing images, the Deerfield design team chose to use text links instead of graphics.

User data showed that over ninety-seven percent of visitors to the Deerfield site have screen resolutions of at least 800 x 600, so developers used that figure as a design standard. Not wanting to alienate users with a lower resolution, however, they placed the main navigation bars where they still can be seen at 640 x 480. The only elements of the layout that may get lost at lower resolutions are secondary ones, such as branding and news announcements. Everything relevant to the selling process is visible at any resolution.

Download time was reduced by cutting the average page weight from 40 to 60K each to 12 to 20K. Further reduction results from using the same images throughout the site; once downloaded, the user's browser simply reloads them onto the next page. Only new text must be requested from the server. Some users display screens using the portrait setting, which tends to truncate the right side of the screen. The Deerfield site meets such challenges by limiting the space allocated to toolbars and other system graphics, and by using the far right portion of the screen only for supplemental navigation.

For almost all body text, Deerfield's V5 uses Verdana, an alternate font designed specifically for screen reading.

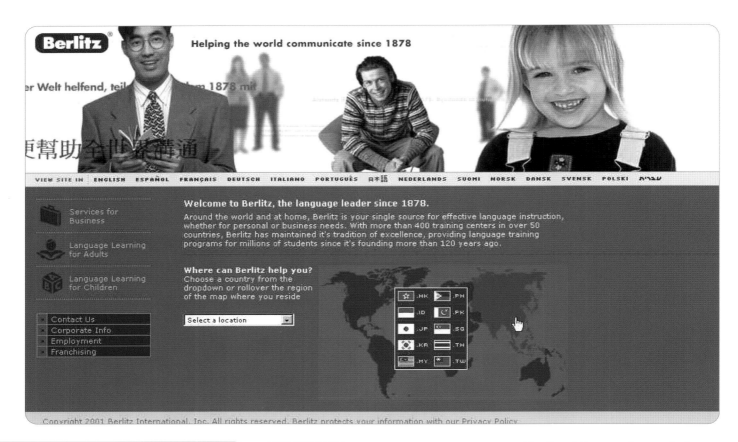

Makeover of global site

Company type: Language instruction, interpretation and translation services

Web site address: www.berlitz.com

Web Design: Dennis Interactive (New York, NY)

<THE COMPANY>

Think of Berlitz and you think of language training. Here and abroad, Berlitz is a well-known and trusted global brand. The company has approximately four hundred franchises around the world, offering language instruction for individuals, as well as interpreting and other translation services for businesses.

<THE SITE>

New York-based Dennis Interactive was charged with revising the global site, as well as creating a template for the language centers around the globe to use. The tricky part is that each language center is a unique business entity unto itself, and therefore needs its own identity; at the same time, each also has a relationship to the corporate parent, and so must visually fall under the Berlitz umbrella. On the previous site, that relationship wasn't so obvious.

"One goal of the revamped site", explains Brian Ripperger, Managing Director, Internet Business Group for Berlitz Language Services, "was not only to serve our customer segments at the global level, but also to provide site experiences that reflect our business unit and customer delivery models. The new site provides information on the global level and on the country level, and also provides information on individual language centers beyond just a Web address."

According to Ripperger, additional goals included offering multiple levels of experience for the customer, keeping it all consistent and keeping it international.

<THE USERS, THEIR GOALS AND THEIR TASKS>

At the outset, Dennis Interactive invested a lot of time identifying users and their main goals. The Berlitz site addresses three very different audiences on the site: one is business-oriented, another is consumer or retail-oriented, and a third, focused on language learning for children, is a combination of the two.

User-based research helped Web team members at Dennis Interactive develop "use-case scenarios" or personas for each Berlitz site (see chapter one for more about personas and user-centered design). Three personas developed were:

User #1: a young, single professional living in New York interested in learning Italian

User #2: a Japanese professional who wants to learn English quickly in order to make a career change

User #3: a mother living in Switzerland whose husband has relocated to the United States and wants their child to learn English

The team followed representatives for each persona through the entire process, documenting every step they took along the way. From there, designers created wire-frames and specific tasks for each page. This organic approach to Web design puts team members in touch with the people who actually use the site, and allows it to grow from the bottom up.

As for hard data, while developers used current technical standards in the United States as the basis for the design (56K dial-up modem, 800 x 600 screen resolution), they also compressed the images and minimized the use of Javascript and Macromedia Flash to make sure the site would run at slower speeds. This ensures that international or less advanced users can access it.

<GOALS OF THE REDESIGN>

In the absence of a global Web initiative, with each language center building their own site, inconsistent implementation was almost inevitable. Berlitz had no central site, just a main homepage and then links to similar sites in ten different languages. Managers customized the content of their site for their own countries, so once a user left the main Berlitz information area and went looking for information on a local site, there was no consistency in the experience, which is a big usability no-no.

The previous Berlitz.com homepage was a portal through which visitors would pass on their way to the franchise of their choice. The trouble was that the passage was lined with general information billboards rather than helpful road signs. The multi-color graphics and animated faces were attractive, but slowed the visitor's progress toward a destination.

One of the goals of the redesigned Berlitz.com was to unite the disparate parts of this widely distributed company in a way to provide flexibility for the franchises and allow Berlitz to convey a unified brand.

Another goal was to deliver appropriate information directly to each type of user, rather than making them hunt for it. This is not an easy task, because visitors come from many cultures, speaking different languages and possessing varied levels of Internet experience. The aim of the new homepage is to provide information for all users *in* the language of their choice, *about* the language of their choice.

The user-centered design process employed by Dennis Interactive brought to

the new site what the old site didn't have: focus. Where the previous site disseminated information rather indiscriminately, the new site promises to deliver information that is pertinent to individual users with specific transactions in mind. The new version's visual design contributes to its improved usability.

The old site was a simple, HTML-based, hierarchically-organized structure with information about basic services. Overall, it was unfocused, and had the feeling of a slide presentation rather than an engaging consumer Web site. For example, information was delivered as simple bulleted lists rather than being packaged and designed.

On the previous Web site, navigation options varied according to which country you visited. One version offered a standard-issue left navigation bar on a yellow background, with simple horizontal rules between each section.

A widely used but even less usable version of a national site included a blue navigation bar on the left, but offered no hierarchy or groupings to help users choose from among the ten options. The rest of the page was filled with graphic banners, which linked either to other areas of the site (repeating options available in the nav bar) or to self-promotion pages. When the site was created, banners were not as stigmatized and ineffective. But banners on Web sites now automatically translate as "advertisements" and are therefore generally ignored by users.

Navigation on the new site is visually consistent and offers a variety of avenues to the same information—crucial features, for a site with such a wide range of users. The most obvious example allows visitors to view the site in any of the fourteen languages. Each language is identified by its own name rather than its English one. This is a small but important detail, and means that some-

one speaking Swedish will be able to easily find information in Svensk, which they'll understand, rather than the English word Swedish. It also clarifies the important distinction between what you speak and what you want to learn.

The navigation bar in the left column of the previous main English page scrolls down indefinitely without providing any clues to the site's organization. Moreover, content is not so much served as splattered. For example, a visitor seeking information about Berlitz English courses on college campuses would be directed—inexplicably—to a page dominated by a Continental Airlines logo and graphic.

On interior pages of the new site, the third column (at far right) is used mostly for secondary content and promotional messages, so users with lower screen resolution won't miss any primary information. This supplementary material supports the main body of text, which in this case is geared toward selling the service. For example, a testimonial displayed in the third column might be relevant to the entire section, and not necessarily page-specific.

If a user doesn't find their language in the navigation bar, they can use the map in the bottom right corner to visually locate their country. Through the use of Flash, scrolling over each continent brings up flags for countries where there is a Berlitz presence and a link to each of the country sites. These bits of Flash are used to enhance navigational functionality on the site. If, however, a user doesn't have Flash, or if they don't realize the map is anything more than a cute map of the world, they have another option: the standard drop down menu listing all the same countries.

Berlitz wanted the new site to create a powerful first impression, so the new homepage includes a noninteractive graphic header that occupies about thirty percent of the viewable screen at 800 x 600 resolution. (On interior pages, the header shrinks to about half that size but still conveys the message.) A usability expert might say it's too much, but in this case the graphic evokes the excitement and joy of communicating across national boundaries. The header incorporates images of different kinds of people from various cultures and of varying ages, with phrases that suggest the power of language.

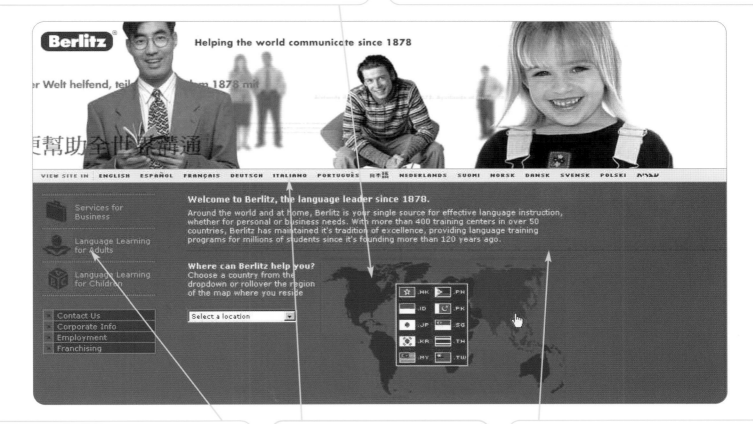

Visitors interested in other services offered by Berlitz, such as interpreting and translation, can select from three options in the navigation bar at the lower left. This box and the one below it become the consistent left navigation bar through the rest of the site.

As on the original global site, the new homepage serves as a portal to local sites, but clear road signs now help travelers reach specific destinations without delay. The first phase of the redesign features fourteen core languages. Visitors may use a horizontal navigation bar centered across the homepage to select the one they want to learn.

Although light type on a dark background can be hard to read, the Dennis Interactive design team decided to use some white text on a dark blue background on the homepage in order to make a greater visual impact.

Original site

Company type: Architectural
engineering company

Web site address:
www.ftl-happold.com

Web Design: Unified Field (New York)

<THE COMPANY>

FTL Happold is an architectural engineering
company that designs lightweight, flexible
indoor and outdoor structures such as band-
shells, tents and canopies.

<THE SITE>

The simple goal of this Flash-based promo-
tional Web site, designed and developed by
Unified Field in August 2001, was to make
FTL Happold's work easily accessible to their
potential customers at any time.

<THE USERS, THEIR GOALS AND THEIR TASKS>

FTL's target market comprises architects and
engineers. Although no formal user research
was undertaken, educated assumptions were
made about this highly-focused user group:
they are business people—some very visually-
oriented—with high-speed modems, standard
screen resolution and all the latest plug-ins.

Visitors who come to the site are usually driven there via an e-mail link, so they arrive with a certain level of familiarity about the company. Their goal is to preview examples of work in the firm's portfolio before deciding whether to make contact.

Flash-based sites generally are frowned upon by usability professionals because their various bells and whistles may often obscure a site's content and purpose. Nevertheless, from Unified Field's point of view, Flash was the best choice for this project because the architects who visit the site were presumed to be design-conscious and technically savvy.

Flash is also the best choice for the site's content, which consists of a historical portfolio—content that isn't likely to change. Ironically, the static nature of the material makes it particularly appropriate for a dynamic, Flash-based presentation because the time and labor invested in its production will provide continuing returns. In contrast, dynamic, database-driven content that changes constantly or is created on the fly needs a more static technology, such as HTML. (Read more about Flash and usability in chapter seven.)

One of the typical constraints of Web design is lack of control over the screen, but Flash allows designers more control when defining the look and placement of screen elements such as type and graphics. Also, Flash-based design remains consistent over all platforms (Mac, PC, Netscape, Internet Explorer), so only one version of the site is necessary.

Flash offers:

- Better feedback. Rollovers help users recognize clickable images by providing immediate visual responses to their actions.

- Better orientation. Because all the action in a Flash movie occurs on one page, the users retain a better sense of where are they are on the site. User anxiety is kept to a minimum when they don't have to jump from one page to another.

- Better (and faster) downloading. Flash keeps file sizes small, loading only what the user needs.

The FTL Happold site employs a very basic color code for active elements. Orange buttons stand out from the otherwise gray-toned screen, summoning the user to action.

Jurors of the ID Magazine New Media Awards celebrated the FTL Happold site not only for its "clean, airy construction," but also for its "faithful adaptation of the company's principles in a manner native to the interactive environment. The simple yet innovative interface has a metaphorical relationship to FTL Happold's work."

The site is designed so that everything fits into a window with 800 x 600 screen resolution. There is no fold, so scrolling is not necessary, and there is no hidden information.

RIGHT HAND NAVIGATION

Although right side navigation is less common on the Web, studies show it allows more ergonomic control for the right-handed majority of users.

Some research shows that users click on topics in the right margin with much more efficiency than topics placed on the left because they are located much closer to the scroll bar. This allows users to quickly move the pointer between the scroll bar and the index items. This benefit is particularly strong for those working on laptops.

The homepage offers some experimental navigation for attentive or adventurous users. Four draggable "cords" frame a rectangular white space in the middle of the screen, representing one of the four areas in the FTL Happold portfolio. The idea is that users can drag any of the cords to any location on the screen, as if preparing to set up a tent. Visitors can click on the labels at the end of each cord, which brings up a list of projects in that field, along with a compact slide show.

Unfortunately, in informal user testing, not one of the users understood how to drag the cords or even understood that the cords were something to interact with—even when the words drag me became visible by rolling the mouse over the icon. "Poor usability," you say, and you may be right. Dragging a cord serves no purpose—it does the same thing no matter where it is on the screen—so there is no logical reason to expect users to even consider such an action.

However, the device does provide users with another option for accessing information (a usability plus), and it connects them to FTL Happold through a creative "tent-making" experience.

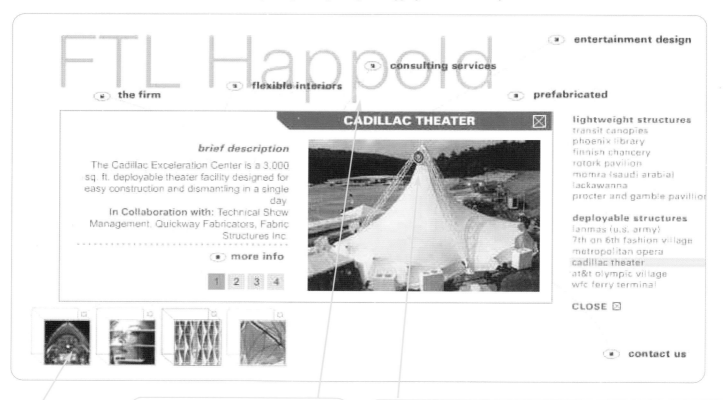

The screen is divided into three areas. The top area is used for primary navigation.

The bottom of the screen holds project highlights with visual cues—an appropriate device for the site's highly visual user group.

The center of the page is used to show the main content of the site—projects and information about the firm and the contact information. Once a portfolio section is open, the area's menu opens on the right side of the page and the content is loaded in the center window. Within each section—prefabricated buildings, consulting services, flexible interiors and entertainment design—an overview and an image are provided, as well as a separate frame with a menu of projects within that category. Projects with links to work in the portfolio and available for viewing are bolded and, when rolled over, highlighted with a yellow bar.

DESIGNING FOR USABILITY IN HTML E-MAIL

HTML e-mail is one of the most complex design mediums on the Web. Not only must one consider how it will work with different browsers, but also every possible e-mail viewing application. Given the complexity of the medium, designers should consider the following guidelines when creating the graphic interface of an HTML e-mail document.

Horizontal Width

Currently, designs should span a maximum width of 600 pixels with a median of 550 pixels. Most users have screen resolutions set at 800 x 600 with a 17" CRT monitor. Outlook Folder List and Shortcuts panels might occupy twenty-five percent of screen space, as would the navigation and sidebars of Web mail systems such as Hotmail and Yahoo. A 600 pixel-wide design would work well in the 1024 x 768 resolution situation that may become more common in the future. In terms of textual layout, the 600 pixel wide format allows for one narrow column on the left or right and one main column for the body.

File Size

When creating a layout for email, the total size of all slices and the HTML file should be no more than 20 to 40K. Email clients are not as robust as Web browsers, and do not show images loading incrementally, so viewers may not be certain whether anything is actually happening. Also people have even less patience with e-mail loading than with Web pages because they are used to the instantaneous rendering.

A common error is to judge file size by the size column in one's e-mail software. This value is merely the size of the code or ASCII characters in the file. Because images are linked to HTML e-mail documents rather than embedded, one must manually add the total file size of all linked images to the file size value to obtain the true size of the e-mail. The ingenious use of HTML color and table tricks can increase the visual impact of an HTML e-mail document without significantly increasing the overall file size.

Design Limitations

Avoid designs that implement a flush left or top alignment. Web-based e-mail providers such as Hotmail, Yahoo and AOL Mail put a ten- to twenty-pixel margin on the left and top of the area where the e-mail message is displayed. Because this margin affects the e-mail from the edges of the display area, the impact of a flush design is ruined. A one-pixel border works well as a design container for e-mail messages.

The Fold

Think of the front page of a newspaper: the most important information needs to appear above the fold. The same is true of HTML e-mail: key content should be positioned within the first three hundred pixels from the top. Most people view messages in the preview pane of their e-mail client, a space with normal width, but reduced height—usually just the first few inches of the document. To make the most of your marketing opportunity, display worthwhile, intriguing content above the fold to entice users into reading further. Besides essential text, items to consider positioning above the fold might include a subscribe form or link, forward to a friend, publication information, or a call to action. In a marketing sense, the content above the fold should intrigue the user enough to read further into the message, if that is the goal.

Core Features

Each design should include the following minimum set of features:

- *Unsubscribe Instructions. These are usually located at the bottom of the document. They should include the subscribed e-mail address of the user for reference.*

- *Subscribe Instructions. Generally located at the very top of the document, these allow new users to subscribe themselves after receiving a forwarded version from a friend.*

- *Date and publication information. These are useful for archive purposes and for legitimizing the publication.*

- *Land-based company contact information. A physical address and phone number provides the user with other means of contact and reassurance that the company is "real."*

- *Forward (or Recommend) to a Friend. Take advantage of viral marketing. The feature can be simply a suggestion that the user forward the issue, or a more elaborate database-driven forwarding system.*

- *Copyright information.*

Typography

According to a 2001 study on HTML e-mail font readability by Dr. Ralph Wilson, Arial (HTML size 3, CSS 14px and print/word processing 12pt) and Verdana (HTML size 2, CSS 12px and print/word processing size 10pt) are the most preferred fonts for readability in HTML email. Using either of these fonts for the body content will increase user satisfaction.

Source: Jhaura S. Wachsman, Consultlogic, Email Publishing Experts
http://www.consultlogic.com/

WHAT GOALS DO FUN SEEKERS HAVE?

■ To spend their leisure time exploring quality entertainment

■ To investigate new technologies and online features

Megan Lane

Demographic: Female, 27, single

Occupation: Senior editor for a national magazine

Personality traits: Curious, open-minded, impatient

Online habits and behaviors: "At home I have a 58K dial-up connection which I use mostly to check my e-mail and bid on eBay auctions. At work we have a high-speed connection (T1 I think). I spend several hours a day online."

Web history: "I used the Web a little in college but not much. It wasn't until I got my first "big" computer in 1996 that I really got into the Web. Before that I had a little laptop without a color display. It had a modem but it was really too slow. When I got my first ISP, I just thought it was the thing to do. It seemed like a waste to have a big fancy computer and not be able to go online."

Favorite Web sites: HOWdesign.com, CityBeat.com (the online version of my city's alternative weekly paper), yahoo.com

Usability pet peeves: Pop-behind windows, opaque navigation, long Flash intros

How do you search? "I tend to hit Google first and try to come up with the most specific search terms possible."

What are your typical online goals? "Usually to find information, but sometimes just to see something cool I've never seen before. I honestly don't know how people got anything done before the Web. I pay bills, I shop (man, do I shop!), I do tons of research for my job, I kill time and amuse myself."

<chapter> 7

FUN SEEKERS

Though users are becoming more task-driven as the Internet carves a place in our lives, there are still a lot of fun seekers on the Web. And nearly every day there's another prediction that the computer will replace or enhance the television as our favorite broadcast entertainment medium.

Indeed, those looking for fun online browse in the same relatively passive way they watch television: they're channel surfing, looking for something new and interesting. Sometimes they have a subject in mind, a particular singer they want to hear or a game they want to play, so it's important to keep links contextual in order to keep these users around for hours. Sometimes they may be more open to following any link that catches their fancy.

Ironically, someone seeking entertainment rather than specific information is likely to be more critical of content quality. Users may tolerate sloppy editorial material and low-quality images when their primary purpose is to transact business; but when a pleasant, fun experience is what they're after, the site had better deliver. On the other hand, because fun seekers expect entertainment destinations such as online games, movie sites and e-zines to have more graphics and interactive features, users tend to be more forgiving about lengthy download times when they're in fun-seeking mode than when they're working.

Fun seekers often have a diverse collection of plug-ins, media viewers and other multimedia software, so an entertainment site is a good place for designers to experiment with adventurous, idiosyncratic navigation. Features with a high "cool" factor only add to the fun—as long as they don't impair usability. The children who make up a large segment of the fun-seeking population should be able to operate a site without too much trouble. If they can't get where they want to go on your site as quickly and easily as possible, they'll go elsewhere.

<MOVIE WEB SITES>

Though marketing-oriented, Web sites designed to promote movies can have tremendous entertainment value. Created by the "theatrical division" of a big movie studio, movie Web sites are analogous to the offline print and audiovisual ad campaigns. The development cycle for such a site is generally very short— a month or two at most—and its shelf life is nearly as brief: maybe three months before the film itself disappears from theaters.

The Web site is often a hybrid of the print and broadcast campaigns, but generally more interactive, which creates usability concerns. Moreover, movie sites have, by far, the widest use of Flash, which can generate usability problems of its own when not used properly or strategically.

Because a film is such a collaborative project, a site's usability is affected by everyone involved: in-house staff, marketing people from the movie studio, film producers, directors, and even leading actors. Other factors that affect usability include the type of movie it is, the type of audience it's expected to draw, and the type of Web experience the film studio wants to offer. Even though demographic information for the movie's target audience may not be particularly relevant to the Web site's target audience, that's all the Web team usually gets. The short development cycle precludes any formal user testing, so friends and family may be recruited for informal trials.

<THE USERS AND THEIR EXPECTATIONS>

Visitors to movie sites expect to be dazzled by multimedia and audio effects, so designers don't have to worry too much about whether they have the requisite hardware or software to handle everything. According to Ed Fladung, a partner at the Los Angeles-based new media firm Mostasa, "Users have a certain expectation that a movie site will be entertaining and more dynamically driven,

It's the navigation that's creative on this site. Users move from section to section using randomized navigation. When you roll over a number, a title appears to indicate which section the number links to. Once you click on a link, the menu disappears into the keyhole and the main content window "moves" to show you the section you have selected.

that it will offer more motion and a more submersive environment than a news site, where the content consists of static images and text." An article by Megan Lane in the February 2002 issue of *HOW* Magazine observes that "movie audiences are open to unusual navigation and creative execution in a way that audiences for corporate Web sites usually aren't." Nevertheless, designers must not entirely ignore the users' capabilities.

To expect someone who doesn't use a computer very often to be able to navigate some movie Web sites is unrealistic. But the studios know that most people over thirty see their movies on home video, and that most viewers who want to see the Web-based previews are under thirty. Because the younger crowd can grasp more complex navigation, designers can give their imaginations freer reign.

<THREE KINDS OF MOVIE SITES>

Some movie Web sites are content-rich, while others are more experiential; but a successful movie Web site should make the user want to go see the film regardless of the site's usability. Many movie sites offer extensive content: information about the making of the film, listings of the cast and crew, interactive features related to the movie's subject matter and positioning, games, online community-oriented activities and viral marketing initiatives. However, the main attraction on most movie sites (and what ninety percent of the users want to see) is the trailer for the upcoming film.

Traditional sites for mainstream movies

The site for Murder by Numbers (2002), a scary Warner Brothers movie starring Sandra Bullock, is pretty straightforward. It includes several areas of interest: *Movie Info, Stills, Cast and Crew, Downloads, Case File, Trailer,* and *Anatomy of a Crime Scene*.

Says Ed Fladung, designer of the site, "We spent time and energy making the navigation relatively intuitive. We tested the site on all different types of monitors, operating systems and connection speeds. We balanced out the color issues by brightening and adding contrast to all the type on the site, paying special attention to the navigation, which is always one click away, in the keyhole site menu."

Each cast members has a page with a photo and biographical information. The small image of Sandra Bullock's eyes peering out at the bottom of the screen represents the site menu, and when rolled over, it brings the navigational numbers back on the screen.

Interactive experiential sites for niche audiences

Some movie Web sites can be as engaging as the films themselves. They're usually the ones that favor intuition and adventure over function and usability. Sometimes it's difficult to know whether you're actually navigating the site, but this is exactly the point. By plunging the viewer into a Web site that they do not completely understand, the designer is challenging them to wander and explore rather than simply searching for information.

For example, the teen horror film *Jeepers Creepers* (2001) targeted to the adventurous, computer-savvy eighteen- to thirty year-old crowd, was designed to be "a little harder to use." With the client's blessing, the designers of the site, Mostasa, tried to push the envelope without losing people.

What makes this site intriguing to use is that there isn't an obvious means of navigation. The only way to travel from screen to screen is by using the space bar. Each screen calls for a different type of interaction, confronting users with a new style of navigation to which they must adapt. Inconsistent? Yes, but it's not like there are no hints—you just have to look closely to find them.

In the lower-right corner of the Flash window, there is a tiny gray question mark. Clicking on it triggers a gray box containing clues about how to navigate the site. The crow scene presents a monster silhouetted against a red background, and two rectangles with blurred images in the middle of the screen.

Rolling over one of the rectangles with a mouse brings the blurred image into focus and and lets the user hear the crow squawking. Rolling off the image makes the blur return. Look closely and you'll notice that a small white line under that box that gets smaller the longer you keep your cursor on the rectangle. When it disappears, the image of the crow remains; after a few more seconds, a new screen appears.

On the left half of the screen, blurred images of the two main characters become clear when moused over. Clicking on the person will make a box containing four images drop down from the top of the screen. A slightly misshapen rectangle also appears on the right side of the screen, along with a little animated diagram that shows how to use this page.

Roll over one of the smaller images and it animates; click on it and a still enlargement appears to the right. Dragging the smaller image to the larger one animates a mini-clip from the film. Each of the smaller images, when dragged to the rectangle on the right, activates a different clip.

"MOVIE WEB SITES ARE A CRAZY PHENOMENON. MY CLIENTS WILL TRY JUST ABOUT ANYTHING NAVIGATION-WISE. **[THEY WANT TO PUSH BOUNDARIES IN ORDER TO SELL THE FILM AND TO ATTRACT ATTENTION.]** THEY ARE CONSTANTLY PUSHING FOR MORE INTERACTIVE AND ENGAGING WEB SITES, AND THEY SEE FLASH AS A STEP IN THE RIGHT DIRECTION. SOMETIMES THEY OVERSHOOT THE MARK BY PACKING TOO MUCH EYE CANDY INTO THE SITES, SLOWING THEM DOWN AND HAMPERING USABILITY, BUT THE ULTIMATE GOAL IS TO CREATE AN EXPERIENCE THAT MAKES THE USER WANT TO GO SEE THE FILM IN THEATERS."

—ED FLADUNG

Sites for a global audience

There are some movies that have expanded into a "product" that has in turn expanded into radio, television, Internet, merchandising, product advertising and more. These movie sites have a longer-than-usual shelf life and they are a global bunch, which makes usability more important. For such a broad audience, the site has to be simple, easy to use and accessible.

On a good site, there will most likely be a navigation menu that gives the user a menu for all the various sub sites. To speed download, the same graphics can be reused on each page—the header and footer graphics, navigation elements, style elements, rollovers—so they don't reload each time. This also helps create continuity across the site and reassure viewers that they are still on the same site. A strategic use of Flash and HTML creates visual interest while retaining the usability of the site. Any useful information should be HTML with a minimalist design style, to allow for quick access.

Originally, each James Bond film had its own Web site and Web address. But the redesigned JamesBond.com is a portal for everything Bond, with a longer-than-normal shelf life and a hungry fan base that must be able to indulge in their Bond fascination without frustration. Already, it has been translated into ten different languages and personalized for individual territories.

Because these sites tend to be more content-heavy than most movie sites—featuring information about the movie, visuals, chat rooms, video games, merchandising, toys and more—they must be easy to navigate and quick to download. Plug-ins are required to view the video offerings and interviews with the cast and crew, but users expect this. Helpful information about the length and file size of each clip lets users decide how to proceed.

In celebration of 007's fortieth anniversary, the Flash introduction to JamesBond.com is a re-creation of 007's famous "iris walk," modified to add some classic Bond style to the more recent Pierce Brosnan look.

This is the final screen of the Flash intro. In previous scenes, the viewer sees Bond initially through a spyglass. He walks onto the screen, then turns to face the viewer and fires a single shot. The spyglass is gradually covered with a red wash, and finally this screen appears and remains static.

The site uses a strategic combination of Flash and HTML. *The initial launch of* Die Another Day, *the twentieth Bond adventure, is almost purely HTML, with a minimalist design style to allow for quick access to information. Production news flashes are presented in HTML, with text, images, clips, and other photos providing a weekly behind-the-scenes look at the filming. After the production wraps, a Flash-based site concentrating on the marketing of the film will provide additional experiences for the user.*

The Flash introduction seamlessly blends into the homepage for JamesBond.com, ending with a navigation menu that lets the user into all the various mini-sites and activities in 007's world. Users can skip the intro and control the sound, if they choose.

ONLINE CLASSICS

Site redesign and upgrade to e-commerce model

Company type: International media company specializing in the arts

Web site: www.onlineclassics.com

Web Design: CollectiveLab, (New York, NY) (www.collectivelab.com)

<THE COMPANY>

Digital Classics is an international media company based in London that specializes in the production, distribution and broadcasting of arts performances.

<THE SITE>

Founded in January 2000, Onlineclassics.com is an Internet broadcaster offering to performing arts lovers worldwide the chance to access their favorite performances via the Internet. Over three hundred hours of full-length operas, concerts, dance productions, and plays are available for viewing at the user's convenience. Three different connection speeds offer choices to meet users' needs: the low-speed streams are free, while high-speed streams are available via subscription or pay-per-view. In other words, for a monthly subscription or per-viewing fee, users receive an audio/video stream of the performance of their choice.

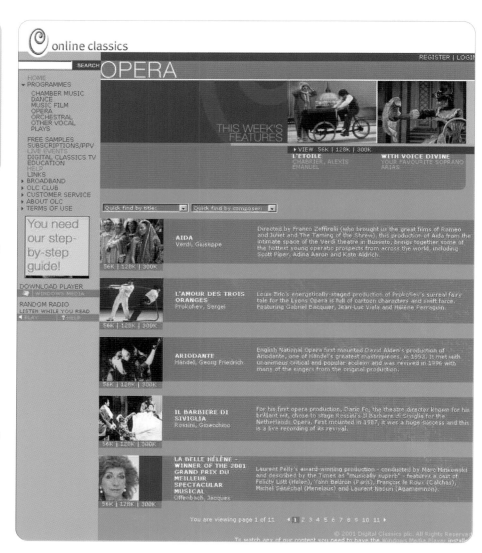

<THE USERS, THEIR GOALS AND THEIR TASKS>

Visitors to this site are devoted to the arts, but not particularly technology-savvy. The most frequently asked question is, "How do I download the Windows Media Player?" (Answers are provided in the *Step by Step Guide to OLC.*)

The audience is truly global: from ninety-five different countries, with the United States and United Kingdom dominating (together, 75%) followed by Asia (12%) and Europe (8%). These opera and theater lovers are generally from an older generation than that which usually goes to the Internet for entertainment. "We have cracked the age barrier. Usually the majority of classical music lovers are forty-five-plus," says Nicole Bachmann, Web site director. 24% of all visitors to Onlineclassics.com are in the twenty-five to thirty-four year-old age group.

<GOALS OF THE REDESIGN>

The purpose of the original site was to provide users with free, immediate access to audio/video streams of arts performances. Although the site was structured to meet that objective, its content was poorly organized. Users had to scroll through long alphabetical lists in order to locate specific artists or performances. In addition, the visual aspect of the site was dark and heavy, dominated by the color black.

When Digital Classics decided to reconfigure its site using an e-commerce model instead of one providing free access only, it engaged CollectiveLab to execute the changes. Not only did the redesign have to improve the site's aesthetic appeal and usability; it had to change the orientation from simply providing content to selling it. The new site, designed with a much lighter, more welcoming atmosphere, gives visitors a better introduction to the high-quality performances available at Onlineclassics.com. The site offers an array of helpful features in addition to reorganized content. A search engine quickly locates specific artists or performances, and a *Free Samples* page allows customers to sample tracks from any genre before they buy. Another section educates users about broadband connections and also provides links to international broadband suppliers.

Color is an important addition to the redesigned site. Not only does it add visual interest—more in character with a site devoted to the arts—but it also provides users with clues to the site's organization. "We always wanted to find a way to differentiate the genres and make the site as exciting and dramatic as possible," explains Bachmann. "That included the use of different colors." To aid navigation, each genre is coded with a different color; varied hues are also used to divide page sections. Because research showed that most intended users have not only broadband connections but also monitors with expanded color capabilities, Onlineclassics.com employs hues beyond the Web-safe palette.

Designers wanted the site's typography to reflect the same visual flair as the other design elements but recognized that because the content includes so much descriptive text, a legible font was absolutely necessary. To assuage designers' aesthetic sensibilities, GIFs are used for the headlines; but to ensure readability for users, the body text is set in Verdana—a Web favorite because it remains legible even at smaller sizes.

Download time is not a major issue for Onlineclassics.com, because allowing users to copy any program content onto their own hard drives would create too many legal and ethical problems. Instead of being downloaded, program content is streamed—delivered directly to the user's computer in the same way television broadcasts are delivered to a TV set via cable.

The user's connection speed determines which streams he or she can watch—it is impossible to watch a 300K stream with a 56K connection, as there is not enough bandwidth available to deliver both picture and sound. An automatic bandwidth tester is in development, but until it becomes available, users must choose their own connection speeds. If they don't know how to do that, the site's step-by-step guide and help pages explain it all.

The primary navigation bar is located at the left of every page. Such consistency is especially useful for older users, who might get confused and disoriented if too much changes from one page to another. The navigation bar contains a drop-down menu for subnavigation through each section. This expandable navigation bar also doubles as a site map, orienting users to what's available where, and making it easier to jump from one section to another.

Because people have different browsing styles, Onlineclassics.com offers a number of different navigation options which permit users to find things naturally. For example, those who know exactly what they're looking for can use the search field, which is located quite visibly in the upper-left corner of the screen, just below the logo. Those who have a genre in mind, such as opera or dance, but who don't have a preference of performer, can use the navigation bar to go directly to the subsection for that genre. Those with no agenda at all, just a desire for performing arts, are most susceptible to the performance features highlighted in the middle of the screen.

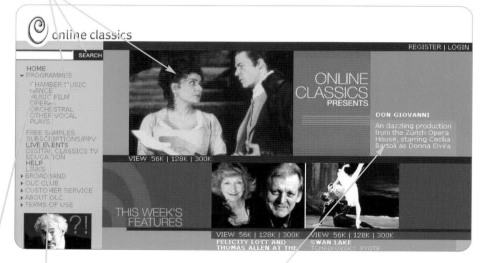

Where the previous homepage consisted of one long, scrolling page with a long list of options on a standard left navigation bar, the redesigned homepage fits the screen, adjusting automatically so that users with wider screens don't get large white fields of wasted real estate. Above the fold, the left nav bar remains in the same place but has been condensed to show only the main categories of interest to users. Since programming is what brings visitors to the site, Programs are at the top.

The rest of the screen above the fold is used to highlight the featured performances, for marketing purposes. This presentation is targeted to visitors who come to the site to browse. The three main features above the fold change twice a week, while the genre features below change weekly.

Almost every image on the site takes users to the main work page of that particular work. Clicking on the 56K, 128K and 300K buttons underneath each picture provides immediate access to the streams—if you're logged in. If a visitor isn't registered, the system will bounce him or her to the registration page.

On interior genre pages such as the Opera homepage, thumbnail images and a bit of descriptive text highlight that week's featured program. Other offerings, each with an associated thumbnail image, are listed less prominently below the fold. Limiting listed programs to ten per page decreases both downloading time and the need for scrolling.

SEVERAL CLASSIC WEB USABILITY PROBLEMS CAUSE FRUSTRATION:

■ *Unclear navigation. Failure to confirm the user's location caused him or her to get lost, either within the site or when leaving it.*

■ *Inconsistent labeling. When various navigation options indicated different names for the same destinations, users found themselves visiting the same feature repeatedly because they didn't realize they had already been there.*

■ *Fancy wording. Users who couldn't understand the descriptions didn't know what to do.*

■ *Nonstandard interaction techniques. This caused predictable problems, such as making it impossible for users to select their preferred game using a "games machine."*

■ *Lack of obvious clickability. Overly flat graphics and similarly modest details caused users to overlook links and thus miss features.*

Makeover

Company type: Entertainment
provider

Web site address:
www.zoogdisney.com.

Design firm: SmartMonkey Media
(Los Angeles, CA)

<THE COMPANY>

Disney Channel, a division of The Walt Disney Company, has a multitude of sites to complement its cable television channels and other entertainment properties. Zoog Disney is one of several sites geared toward kids.

<THE SITE>

ZoogDisney.com, branded *TV You Do*, is a fun and games convergence of television and Web site, featuring cartoon characters who live in the "Zeather," a fiber-optic world between the television and the computer.

The characters are the Disney Channel's interstitials, transitional figures who serve as hosts to bring kids into and out of each TV show. They do the same on the Web site.

Says Ani Phyo of SmartMonkey Media, an experience design firm in Los Angeles, "I love designing for kids because it allows for more creative freedom, a wider range of visual cues such as sound, color, shape, animation. Kids' sites can be more entertainment-oriented, whereas adult sites tend to be tools that need to function efficiently to help them get their task done quickly."

<THE USERS, THEIR GOALS AND THEIR TASKS>

The target audience for this Web site is *tweens*: kids between the ages of eight and twelve who are not quite children anymore, but not yet teenagers either. This relatively newly-identified demographic group is notorious for having an extremely short attention span—kids watch television while surfing the Web, painting their fingernails, and talking on the phone—and a desire for dynamic content, video, animation, graphics and visuals. Unfortunately, however, most of them are surfing the site from home on hand-me-down computers, outdated software and slow dial-up connections.

One of the most popular activities (or "tasks") on the site is playing games. But to play, there are pretty hefty software requirements: Internet Explorer or Netscape (4.0 or later), Flash 5 and Shockwave 7. Quicktime and RealPlayer are suggested but optional. The site's help page, reached through a tiny text link in the upper-right corner of every page, suggests that users must have at least a 28.8K modem, though they recommend 56K, DSL or a cable modem.

Here's how the site explains the hardware and software requirements in its kid-oriented language:

Here's the handy rule: the bigger your monitor resolution, the MORE you get to see. The minimum recommended resolution is 800 x 600. Sure, everything should still work if you're checking things out at a lower res like 640 x 480—it just won't be as cool-looking. Same goes for the number of colors. If you only have 256 colors, it's not going to look very nice. Try setting it to 65,000 colors instead (that's "thousands" of colors, on a Mac). That should be plenty!

If you have to do a lot of scrolling around in Zoog Disney, ask your parents if it's possible to adjust your monitor resolution.

Because this audience often has the TV literally right next to the computer, Zoogdisney.com seeks to fully integrate the familiar TV cartoon characters into the Web site, creating an endless loop whereby they interact with television programs by visiting the Web site to play a game, vote or answer a question. Results and responses can then be posted on television.

In order for the concept to work, however, kids must be able to go to the site and quickly drill down to whatever they need. Unfortunately, the original site was too cumbersome for kids to use easily.

On the previous site, pages were too heavy for the tween audience's dial-up connections; the result was a lot of frustrated kids. In fact, the site got complaints, and these users didn't hold back. "We hate this site," they wrote.

\<GOALS OF THE REDESIGN\>

SmartMonkey Media was called in to trans-form Zoogdisney.com into a rich media site that functions and streams content efficiently, and has good usability and good information design.

Zoogdisney.com's most basic problem was that the entire site was designed as a single Flash movie. In Phyo's opinion, this is never a good idea. "Anytime anything is done as one large movie, it is harder and less efficient to update."

Efficient updating is essential to this site because any material for children—particularly tweens—needs to be constantly refreshed and renewed. Making changes to an entire Flash movie is expensive, time-consuming and labor-intensive. When a presentation is built in pieces, however, one piece may be updated without having to remake the whole movie.

To solve Zoogdisney.com's problems, the SmartMonkey Media team created templates for everything on the site. Templating means providing a framework into which specific content elements can fit. With a template, each element remains in the same area and functions in the same way on each new page. This consistency allows users to quickly develop a mental model of how the site's virtual space is structured and how its func-tions should operate. Templating also makes it easier for developers to update content, add pages, and create new sections. When each content area functions independently, calling in Flash animation or GIF and JPEG files only as needed, the whole design can be more flexible and dynamic.

Because this TV and Web site convergence was targeted at tweens, it needed lots of character animation and audio to grab their attention, as well as user feedback mecha-nisms. Templates helped designers achieve these objectives without sacrificing usability.

The homepage, top-level and even lower-level pages use similar templates. The difference is that on lower-level pages, the center area holds one large item instead of several smaller content pieces. Properties of any media assigned to a specific area are the same for those assigned to other areas, facilitating media exchanges around the site. Because each templated component is inde-pendent, updating is much easier.

With the help of user feedback and focus groups, SmartMonkey Media redesigned Zoog Disney's online and broadcast convergence so successfully that site traffic doubled with-in a few months. Thanks to Disney marketing power and frequent exposure on Disney television channels, the Web site now boasts seventy thousand regular users and over one million page requests daily.

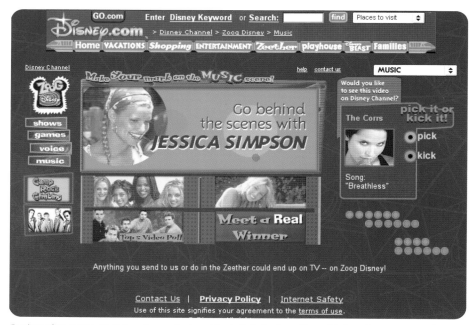

In place of an entirely Flash-based page, the template dedicated only portions of it (here the center screen) to Flash, not just to be cool but to accommodate the interactivity and rich streaming media.

USABLE FLASH

There are three basic criticisms against Macromedia Flash content being usable:

- *Flash content is generally gratuitous, superficial and annoying.*
- *Flash content is generally built once and not updated.*
- *Flash content does not adhere to many of the established standards for Web content.*

Each of these arguments has a basis in fact. The totality of Flash content currently deployed on the Web provides ample justification for these arguments. However, the reason that usable Flash is not a myth is that the critics have focused on what designers have actually done with Flash, rather than on what can be done with the product.

Reasons for using Flash

You must ask whether the needs of the project can suitably be fulfilled with Flash content. Is Flash the best format for the content? Do other tools—such as plain HTML—offer a better, more effective method for achieving the project's goal? Is the offer strong enough for users to be willing to put up with the potential hurdles they might encounter?

Flash content deployed on the Internet should be usable to the greatest possible number of users. This may mean developing for an older version of the Flash plug-in, high and low bandwidth versions of the content or a non-Flash version. Flash deployed inside a more controlled environment like a corporate intranet or a broadband portal can have a higher set of specs to meet. Flash presented on kiosks or in a stand-alone projector file is in an even more controlled environment, thus it has a higher set of specs. Media needs for the project will also factor into the decision to use Flash. Does the project require sound or voice-overs? Will there be XML integration or animation required for the project?

Benefits of Flash

Flash offers many benefits that other interactive Web formats can not compete with, such as compatibility and stability unparalleled by other Web formats.

In terms of file size, the use of vectors to define objects makes them smaller than their bitmap equivalents. Vectors are also scalable—meaning that the file size and image clarity will remain the same at whatever resolution it is displayed.

Flash offers a tight integration of multimedia content in a single file

format. Other features make it a powerful Web development product including XML support, server-side application support, printing, forms and dynamic content.

The use of vector information means that scaling can be done without distortion or increased file size. Scaling also allows Flash to use information from one source, taking away the need to reload page after page.

Flash also offers concrete benefits to users by decreasing download times and offering more intuitive access to information.

Design tips

Use it with HTML. The capacity of Flash content to interact with data-base content, provide complex interactivity at a small file size and respond to external actions makes it an excellent product for quickly adding functionality to standard HTML pages. Use Flash content as navigation or instead of unstable Java applets to improve the user experience.

Establish a visual hierarchy and stick to it. Users need visual cues to identify what part of the design is for content, what part is navigation and what is everything else. Create a visual hierarchy for content and stick to it. The user will find comfort in the familiarity and their ability to use the content will improve.

Make the navigation clear. The navigation within Flash content should be efficient, effortless and crystal clear to the user. Users should have no question as to what information any button will lead them to.

When designing navigation, remember that it serves not only to tell users where they may go, but also where they are and where they have been. As a developer, you should always provide the user an exit and access to the major sections of the content at each phase of the navigation. Avoid designing hidden navigation that is only apparent once the user has triggered an event.

Other Resources

Flash 99% Good: A Guide to Macromedia Flash Usability (Osborne McGraw Hill, 2002) by Kevin Airgid & Stephanie Reindel

The companion site www.flash99good.com is a self-proclaimed "first aid manual for usable Flash design." Check out the Bad Case Study for examples of what doesn't work in Flash.

Excerpted from "Developing User-Friendly Flash Content" by Chris MacGregor, April 2001 (www.flazoom.com/usability)

SITES FEATURED

Ashford www.ashford.com p. 62

Bambino's Curse www.bambinoscurse.com p. 89

Becoming Human www.becominghuman.org p. 48

Bob Bly www.bly.com p. 16

Berlitz, Inc. www.berlitz.com p. 114

BreastCancer.org www.breastcancer.org p. 32

Castor & Pollux Pet Works www.castorpolluxpet.com p. 58

Consumer Reports www.consumerreports.org p. 66

Deerfield, Inc. www.deerfield.com p. 111

Design for Community www.designforcommunity.com p. 86

ExploreMath www.exploremath.com p. 41

FTL Happold www.ftl-happold.com p. 118

Government of Alberta (Canada) www.gov.ab.ca p. 37

H&R Block www.hrblock.com p. 94

Herman Miller www.hermanmiller.com p. 22

International Herald Tribune www.iht.com p. 25

International Institute of Applied Aesthetics
www.lpt.fi/io p. 17

James Bond www.jamesbond.com p. 128

Jeepers Creepers www.mgm.com/jeeperscreepers p. 126

Murder By Numbers
http://murderbynumbersmovie.warnerbros.com p. 125

Nerve.com www.nerve.com p. 82

Online Classics www.onlineclassics.com p. 130

Schwab Foundation for Learning p. 75
www.schwablearning.org

Smith & Hawken www.smithandhawken.com p. 54

Staples, Inc. www.staples.com p. 69

The Wall Street Journal Online www.wsj.com p. 44

Transportation.com www.transportation.com p. 98

Tripwire, Inc. www.tripwire.com p. 108

VolunteerMatch www.volunteermatch.org p. 78

Zoog Disney www.zoogdisney.com p. 134

ADDITIONAL RESOURCES

Use these additional resources for further information on Web site usability.

<WEB SITES>

Cooper Interaction Design www.cooper.com
Digital Freedom Network www.dfn.org
Flazoom www.flazoom.com
Good Experience www.goodexperience.com
Usability.gov www.usability.gov
Usable Web www.usableweb.com
Useit.com www.useit.com
User Interface Engineering www.uie.com
Web Monkey www.webmonkey.com
Web Page Design for Designers www.wpdfd.com
Lynda Weinman www.lynda.com

<BOOKS>

Flash 99% Good by Kevin Airgid, Stephanie Reindel
User-Centered Web Design by John Cato
Human Factors and Web Development by Chris Forsyth et al.
Web Redesign: Workflow That Works by Kelly Goto, Emily Cotler
Don't Make Me Think by Steve Krug
Designing Web Usability by Jakob Nielsen
Homepage Usability by Jakob Nielsen, Marie Tahir
The Design of Everyday Things by Donald Norman
The Wireless Web Usability Handbook by Mark Pearrow
Information Architecture for the World Wide Web by Louis Rosenfeld, Peter Morville
Back to the User: Creating User-Focused Websites by Tammy Sachs, Gary McClain PhD
Experience Design by Nathan Shedroff
Web Site Usability by Jared Spool
The Art and Science of Web Design by Jeffrey Veen
Small Pieces Loosely Joined by David Weinberger
Designing Web Graphics 2 and 3 by Lynda Weinman
Taking Your Talent to the Web by Jeffrey Zeldman

<ORGANIZATIONS>

Association for Computing Machinery (ACM) Special Interest Group on Computer–Human Interaction (SIGCHI) www.acm.org/sigchi
Society for Technical Communication www.stc.org
Usability Professionals Association www.upassoc.org

<ONLINE FORUMS AND WEBLOGS>

Boxes and Arrows www.boxesandarrows.com
CHI-WEB—an ACM SIGCHI moderated discussion list
 www.sigchi.org/web
Elegant Hack www.eleganthack.com
Xblog http://xplane.com/xblog

<MAGAZINES>

Edesign www.edesignmag.com

<DESIGN AND CONSULTING FIRMS FEATURED>

37Signals, Chicago, IL www.37signals.com
BBK Studio, Grand Rapids, MI www.bbkstudio.com
GV Brown & Assoc./Intervail, Traverse City, MI www.intervail.com
Consultlogic, Carpinteria, CA www.consultlogic.com
CollectiveLab, New York NY www.collectivelab.com
Michael Dahlstrom Photography, Portland OR
 www.dahlstromphoto.com
Foraker Design, Valhalla NY www.foraker.com
Mostasa, Los Angeles, CA www.mostasa.com
Powazek Productions, San Francisco, CA www.powazek.com
Small Pond Studios, San Francisco, CA www.smallpondstudios.com
Smart Monkey Experience Design & Direction, Los Angeles, CA
 www.smartmonkey.com
Terra Incognita, Baton Rouge, LA www.terraincognita.com
Tweak Interactive, Portland, OR www.tweakinteractive.com
Unified Field, New York, NY www.unifiedfield.com
VML, Inc., Kansas City, MO www.vml.com

INDEX

A

Ashford, Inc., 62–65
Ashford.com, 62–65

B

Back buttons, 25
Bambinoscurse.com, 89–91
Bandwidth, 22
Banking, online, 97
Becominghuman.org, 48–51
Berlitz, 114–117
Berlitz.com, 114–117
Breastcancer.org, 32–35

C

Canvas size, 21
Cascading stylesheets (CSS), 27
Castor & Pollux Pet Works, 58–61
Castorpolluxpet.com, 58–61
Census of people online, 17
Choices, 23
CollectiveLab, 130–133
Colors, 21, 28
Companies. see Organizations
Consistency, 23
ConsumerReports.org, 66–68
Consumers Union, 66–68
Contingency design, 102

Control, 24
Conventions, 21

D

Deerfield, Inc., 111–113
Deerfield.com, 111–113
Dennis Interactive, 114–117
Design for Community, 74, 86–88
Design principles, 23–29
 back buttons, 25
 cascading stylesheets (CSS), 27
 choices, 23
 colors, 28
 consistency, 23
 control, 24
 graphics, 26
 instruction, 23
 interaction, 23
 layout, 26–27
 navigation, 24, 25
 pop-up windows, 25
 text, 26
 web-safe colors, 28
Designers
 Alberta Public Affairs Bureau, 37–40
 Ashford, Inc., 62–65
 CollectiveLab, 130–133
 Consumers Union, 66–68

 Deerfield, Inc., 111–113
 Dennis Interactive, 114–117
 ExploreLearning, 41–43
 Foraker Design, 32–35
 Nerve, 82–85
 Powazek Productions, 86–88
 Small Pond Studios, 75–77
 SmartMonkey Media, 134–136
 Smith & Hawken, 54–57
 Staples, Inc., 69–71
 Terra Icognita, 47–51
 37signals, 98–102
 Tweak Interactive, 58–61, 108–110
 Unified Field, 118–120
 VML, Inc., 94–97
 VolunteerMatch, 78–81
 Wall Street Journal, 44–47
Designforcommunity.com, 86–88
Digital Classics, 130–133
Disney Channel, 134–136
Download speed, 22

E

E-Commerce site checklist, 71
ExploreLearning, 41–43
ExploreMath.com, 41–43